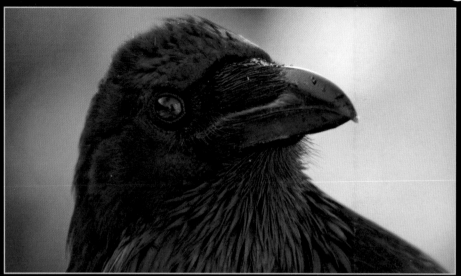

Tulugaq

An Oral History of Ravens

For River.

Published by Inhabit Media Inc.
www.inhabitmedia.com

Inhabit Media Inc. (Iqaluit), P.O. Box 11125, Iqaluit, Nunavut, X0A 1H0
(Toronto), 146A Orchard View Blvd., Toronto, Ontario, M4R 1C3

We acknowledge the support of the Canada Council for the Arts for our
publishing program.

 Canada Council Conseil des Arts
for the Arts du Canada

Printed in Canada

Library and Archives Canada Cataloguing in Publication

McCluskey, Kerry, 1968-, author
 Tulugaq : an oral history of ravens / by Kerry McCluskey.

ISBN 978-1-927095-15-7 (pbk.)

 1. Ravens--Canada, Northern--Folklore. 2. Ravens--Canada,
Northern--Folklore--Pictorial works. 3. Canada, Northern--Folklore.
4. Canada, Northern--Folklore--Pictorial works. 5. Inuit--Folklore.
6. Inuit--Folklore--Pictorial works. I. Title.

GR735.M33 2013 398.2'4528864 C2013-904365-9

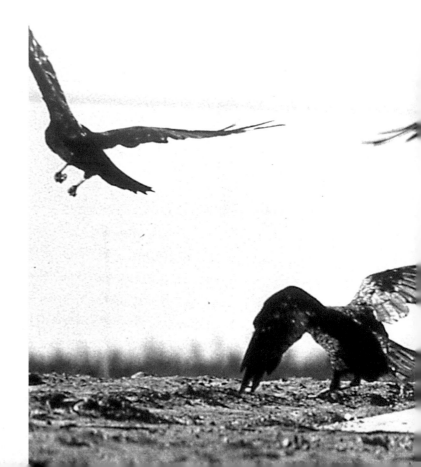

Tulugaq

An Oral History of Ravens

Kerry McCluskey

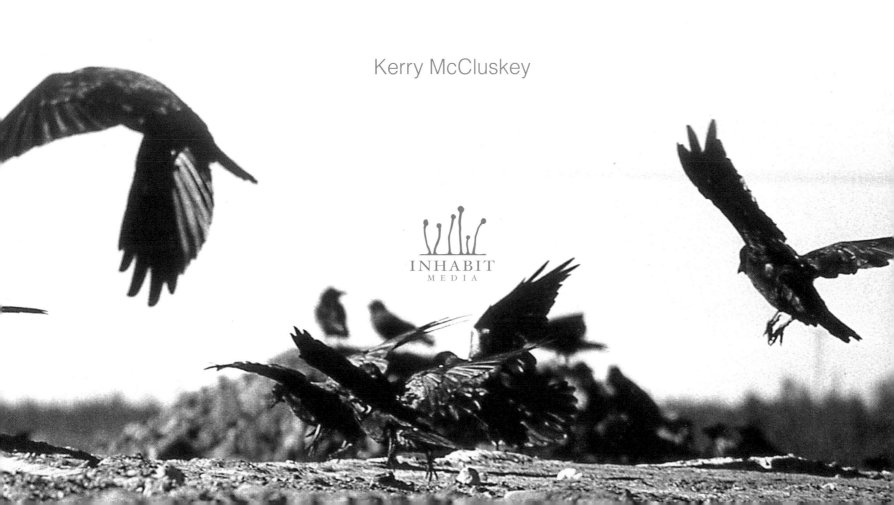

INHABIT
MEDIA

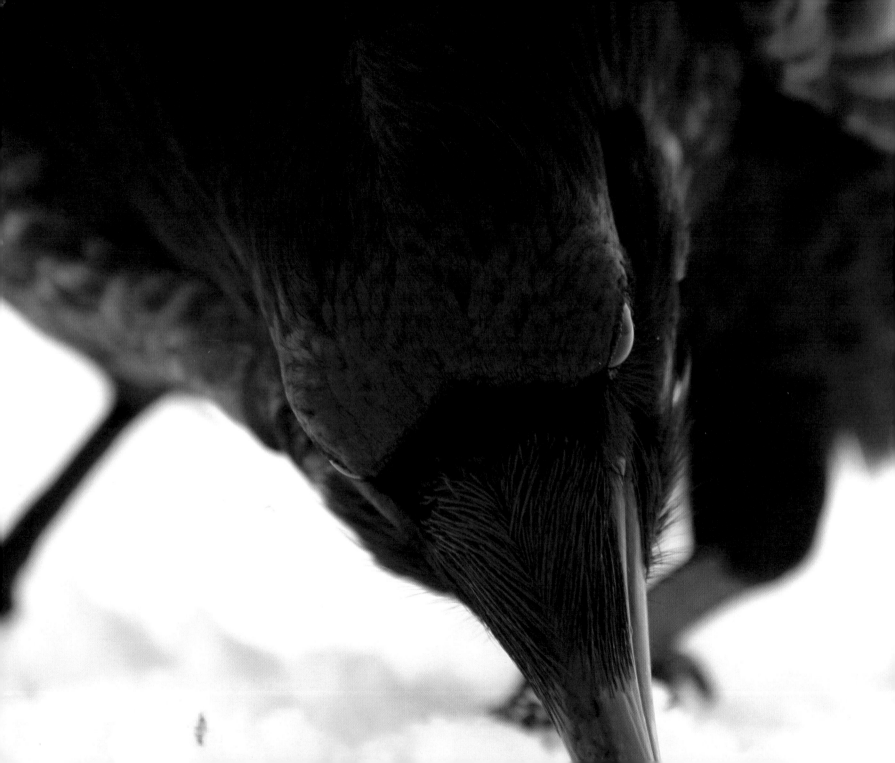

Introduction

Ravens are known for many things, but rarely as a cure for homesickness.
But it is this curative ability that caught my attention and led me on an Arctic adventure. In 1993, I left Ontario in pursuit of excitement in Yellowknife, Northwest Territories. I had graduated from university the year before, and I figured I could transfer my part-time waitressing career from south to north. I was right: within days of landing in Yellowknife, I was employed as a part-time server at a popular Italian eatery.

While I jumped headfirst into my new life under the midnight sun, I wasn't prepared for the homesickness that set in. One afternoon, when I was feeling particularly lonesome, I sat in my room in the boarding house I was calling home. I longed for conversation with my mother or my best friend, but the telephone in the room wasn't hooked up and it was a hike to the nearest pay phone. As I sat feeling sorry for myself, I thought I heard the phone in the room ring. Thrilled, I ran to answer it, but was greeted with silence: no caller, no dial tone. This happened a few more times. I'd hear a phone ring, I'd run to answer it, and I'd always be greeted with silence.

On one such occasion, I threw my head back in exasperation, and saw a raven perched in a tree directly outside the open window opening its beak and mimicking the sound of a phone ringing. I was awestruck. I had no idea that ravens were so clever, or such skilled mimics. I told more and more people the story, and every time I shared the tale, people would respond with a raven story of their own.

From then on, I was smitten with raven antics, and I looked for a collection of northern raven tales. Finding nothing, a seed formed, eventually growing into *Tulugaq*. After moving from Yellowknife to Iqaluit in 1998, I started collecting stories and found that what I had suspected was indeed true: almost every northerner has a raven story and is waiting for the opportunity to share it.

The pursuit of these stories took me from Arctic coast to Arctic coast, from Iqaluit to Arctic Bay, over to

Rankin Inlet, Inuvik, Whitehorse, and Skagway, Alaska. I ate gourmet food at a restaurant called The Raven; I was stranded by the 9/11 disaster; I spent many days at landfill sites across the north; and I was blessed to interview dozens of northerners, including many Aboriginal Elders. The first legend I recorded came from Inuk Elder Mabel Ekvanna Angulalik. The interview took place at her home in Cambridge Bay. As Mabel spoke, I became emotional as it dawned on me that this was really happening, that *Tulugaq* was becoming a reality. My awe and gratitude persisted as I sat at dozens of kitchen tables over strong black tea, listening to the lyrical words of the legends, most often told in Inuktitut or Inuinnaqtun. I often imagined the circumstances under which the storytellers originally heard these legends: huddled together as children in an iglu or a tent, drawing warmth from a lit *qulliq* or Coleman stove, being entertained and listening as their mothers and fathers and grandparents and great-grandparents told them stories.

Several common themes emerged from these interviews. Like English fables or fairy tales, the stories were passed on orally from one generation to the next to teach children and younger people social customs, acceptable behaviours, laws, and survival and safety techniques. Many of the stories inspired fear in children to encourage them to behave properly. Stories taught children not to leave tools, clothes, and food unattended, susceptible to damage or theft by scavengers. The stories taught the virtues of not having too much pride, helping Elders, sharing food and clothing, and taking care of one another. Very often, the importance of finding a mate and producing children was conveyed in raven legends, predicting dire results if a woman waited too long to find a mate, or chose to remain unattached and childless. Survival depended upon continued reproduction and the creation of large family groups, so coupling and children were of paramount importance. Very often, the stories ended with tragedy or death when the warnings were not heeded.

Another important theme present, particularly in my conversations with Inuit Elders across the Arctic, was that of the raven guiding hunters to animals. Many Inuit spoke of how ravens will dip their wings in a certain way when they spot a polar bear or caribou, indicating to hunters that animals are nearby. Inuit deeply respected and appreciated this quality, as much as the raven would have appreciated the leftover scraps it would get once the animal was harvested.

Storytellers used the raven's physical and personality traits to explain the creation of the world and its inhabitants. Ravens often switched back and forth from raven to human form, and the stories often characterized ravens as untrustworthy tricksters. Stories described how ravens came to be black and have small eyes, why the fox walks with a hop, how the wolverine is the fiercest of animals, where the ravens went when Noah's ark set sail, and how the earth, sun, and waters were created. Occasionally, the Elders would tell their stories and sing the songs of the raven in a lyrical warble and mimic the walk and the flapping of wings. These times were magical. Elders sometimes

said that they used to remember more stories about ravens, but they had already forgotten them. It struck me that much of the raven's oral history had already faded.

This ancient connection to ravens created and nurtured a profound respect among generations of storytellers. Landfill sites came with the transition from a nomadic lifestyle to community living, providing a ready source of food for the birds, and resulting in a prolific population increase of ravens across the north. Instead of dipping their wings to point to a polar bear, ravens are now more likely to steal your dog's food and dive-bomb your truck windows.

This doesn't mean that modern raven folklore entirely reviles the raven. Contemporary urban legends were passed on to me with great excitement, and were often accompanied by a sense of eerie disbelief. Again, it was usually over a kitchen table or on a comfy couch that the younger storytellers told me they were amazed by their spiritual encounters with ravens. Many of the modern urban legends fete the raven as a humorous trickster and celebrate its proficiency as a thief and teaser of animals.

As I travelled across the Arctic in pursuit of these stories, I was impressed by the strength and determination of oral folklore and how the same raven stories were known and shared among Inuit and First Nations storytellers in remote and unconnected communities, all without the assistance of telephones or modern forms of communication. Inuit in Iqaluit and Arctic Bay, as well as other communities, sing the same song about a raven flying with a human leg in its mouth, refusing to share its catch with others. Toward the end of the research, I realized that regardless of culture, ethnicity, location, age, or whether it is expressed in an ancient legend or a contemporary experience, people in the north strongly believe in the magic of ravens. I feel lucky to get to play a role in passing on these stories.

Tulugaq came full circle a few years ago at a dinner party in Iqaluit. Guests were telling raven stories, and the host shared what she called an urban legend. Over mushroom risotto, she talked about a raven sitting in a tree outside an open window, tricking a woman into believing the phone was ringing. It was one of those delicious moments in life when you know that the path you're on is exactly the right one. I hope readers enjoy *Tulugaq* as much as I have.

Kerry McCluskey
Iqaluit, Nunavut

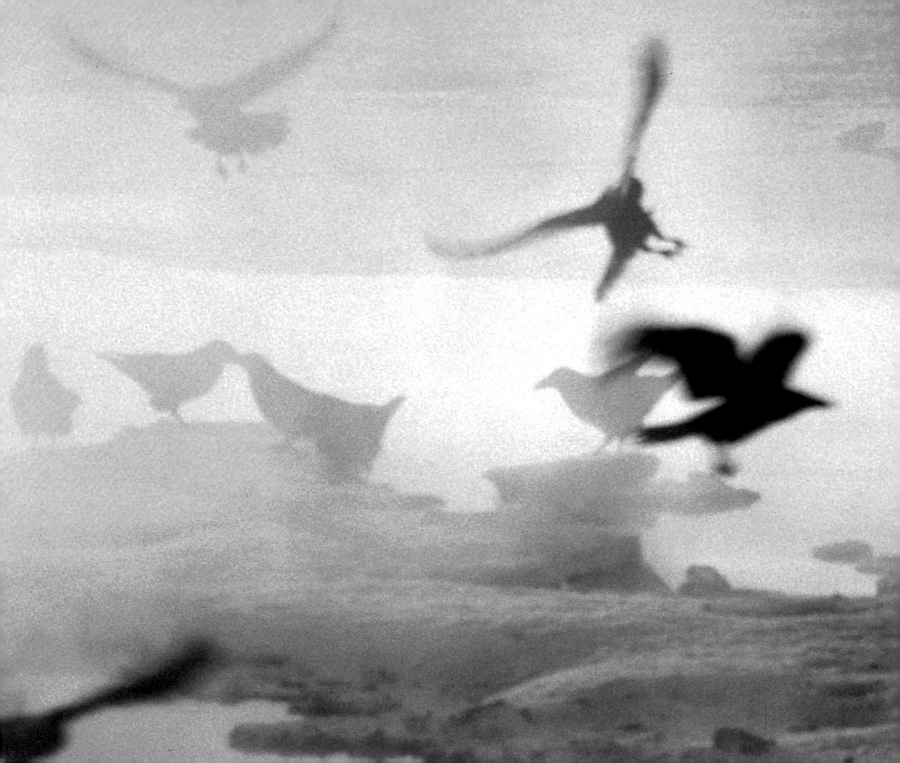

1.

Creation

An old-time legend goes as follows. One day, there was a raven flying all by himself in space. All of a sudden, it started to snow. This was a giant, huge raven. This raven spread his wings out and said, "I'd sure like to rest. I've been flying for infinity. I'd really like a place to rest." Instead of flapping his wings out in space, he started to glide. As he glided, snow gathered on his wings and he tipped over to one side.

Immediately, the snow started to fall from the higher wing and a little avalanche began. A small ball of snow gathered, and by the time it reached the other wing, he flung it out into space. As he flung it out into space, it gathered more snow. This snowball got so big that the raven could land on it. The raven landed there and it was dark and cold, but at least he had created a place where he could land and rest his wings.

The raven said to himself, "I have to have light. It's too dark. I need to see." So the raven pecked on the ground a couple of times, and immediately a plant started growing. The raven could see something very bright growing inside the plant. The raven, who was facing south, grabbed this bright object with his left wing and flung it to his left. That became the sun.

Later, as the sun set, the raven said that the night was too dark and he needed some light to see. The raven pecked on the ground, and immediately a plant came out of the earth. There was a light inside the plant, but it wasn't as bright as the first plant. It was silvery and dimmer than the first light. The raven took the bulb of this plant with his right wing and flung it to his right side. The raven had light for the evening. He had created the moon.

The next day, the raven said, "I need a partner on earth." He pecked on the ground and a plant came up. He pecked at that plant, and when it opened up, there was a human there. The raven went up to the human's nostrils and breathed life into it. This became a woman. The raven was very pleased with himself.

He said to the woman, "I am your husband."

The woman said, "But you are a raven."

So the raven said, "All right, I'll take off my raven form." He pecked on the ground and stood straight up. His raven form folded back and a human face appeared. The rest of his wings became a coat. That's how the raven created the universe. Then he and his wife named all the animals and plants and came up with Inuit law, which we still follow today.

Roy Goose
Cambridge Bay, NU

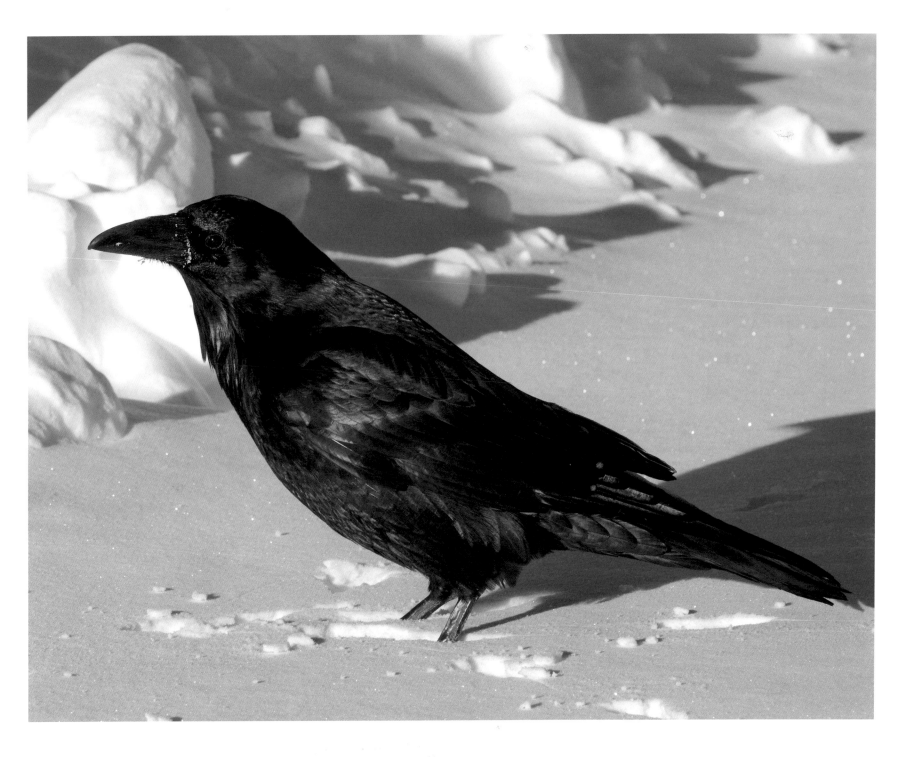

I don't remember where I learned the legend, but I find it interesting. It's about the raven and the owl.

They used to have feasting in the north when the hunting was successful. Everyone would gather all together and there would be drum dances and a big feast. There were once two Elders who were neighbours. They were too old to go to the feast, so one of them went to visit the other. They were very old.

The Elder who came to visit told the other Elder, "Why don't we dress up together just like young girls do? Let's pretty up ourselves."

The other one said, "Oh yes, yes, we can do that."

The woman who came to visit had a long nose and little eyes. The woman who lived there had a short little nose and big eyes. The little old lady with the long nose and the little eyes started to pretty up the little old lady with the short nose and the big eyes. She was using soot to pretty her up and paint her. The little old lady with the short nose and big eyes was quiet and patient, and she didn't move an inch. The old woman with the long nose and little eyes finished dressing her all up.

The little old lady with the short nose and the big eyes said to the little old lady with the long nose and the little eyes, "Let me pretty you up."

The little old lady with the long nose and the little eyes said, "All right."

The little old lady with the short nose and the big eyes started to pretty up the little old lady with the long nose and the little eyes.

But the little old lady with the long nose and the little eyes moved and said, "Ouch." The little old lady with the short nose and the big eyes said to the little old lady with the long nose and the little eyes, "If you move again, I'm going to pour that soot all over you and you will no longer be pretty, so stay still."

The little old lady with the long nose and the little eyes said to the little old lady with the short nose and the big eyes, "Okay." She started to pretty her up again, but for the second time, the little old lady with the long nose and the little eyes said, "Ouch."

The little old lady with the short nose and the big eyes said to the little old lady with the long nose and the little eyes, "If you move once more, I am going to pour that soot all over you and you are going to become ugly." The little old lady with the long nose and the little eyes wanted to be pretty, so she tried to stay still.

Once again, the little old lady with the long nose and the little eyes moved and said, "Ouch." So the little old lady with the short nose and the big eyes poured that soot all over the little old lady with the long nose and the little eyes. They never talked to each other ever again. One is the wise owl, and the other one is the raven, with all the

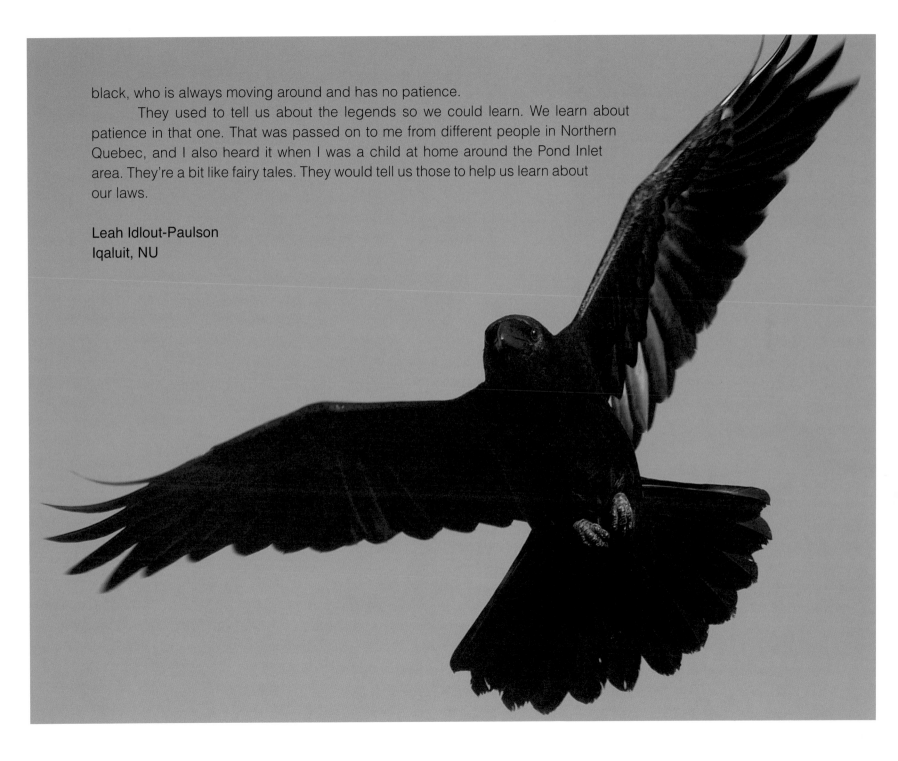

black, who is always moving around and has no patience.

They used to tell us about the legends so we could learn. We learn about patience in that one. That was passed on to me from different people in Northern Quebec, and I also heard it when I was a child at home around the Pond Inlet area. They're a bit like fairy tales. They would tell us those to help us learn about our laws.

Leah Idlout-Paulson
Iqaluit, NU

One time there were a fox and a brown bear living together in the same camp, the same tent. One summer, food started getting scarce. The bear had the front leg of a caribou on his side of the tent, and he didn't want to share. The fox started telling stories to the bear. The bear fell asleep. The fox was hungry, so he went for the food.

While he was taking it, the bear woke up, and he wasn't happy. The bear took the meat, and took the front leg of the fox as well. The bear took off in his *qajaq* to one of the islands. The fox was left alone in the tent for a few days, and he was hungry.

One day, the fox could hear somebody coming by qajaq, talking away. He could hear somebody walking up to the tent, and in came the raven. The raven asked what happened. The fox said the bear took his leg and then took off to an island. The raven was curious about what had happened to the fox's leg. He left by qajaq to the bear's camp. When he got to the bear's camp, he went into the tent. He could see the fox's leg beside the bear.

The raven started telling stories. The bear fell into a deep sleep and started snoring. The raven grabbed the fox's leg and took off in his qajaq. He also pushed the bear's qajaq out into the ocean. The raven paddled back to the fox's camp and walked into the tent with the leg. The raven told the fox he was going to put the leg back on and that it was going to hurt. He started walking toward the fox, but he tripped and misplaced the fox's leg. Still today, the fox walks and hops kind of funny.

Attima Hadlari
Cambridge Bay, NU

There were all sorts of animals that people hunted in order to survive. Animals, too, had spirits. When the earth was formed, Inuit communicated with the animals and harmonized amongst one another. Each and every animal ate separately. Every animal was the raven's favourite catch, especially the animal's feces when it was frozen solid.

This is what I heard from my Elders and their Elders before them.

Moses Koihok
Cambridge Bay, NU

The raven and the oopik were in the iglu having fun. The oopik was painting small marks on the raven. Then the oopik gave his *kamiks* to the raven. The raven was so happy that he was dancing. The oopik wanted to paint more marks, but the raven did not stand still. So the oopik turned the bucket of black paint over the raven's head. That's why today the raven is black.

Chuck Pizzo-Lyall
Taloyoak, NU

The raven is my spirit guide. It's also the bird that is the most impressive. It's the bird that is a year-round resident; it recycles, and is the most intelligent bird on the face of the earth. What do you see when you look out your window at 60°C below? You see the raven dive-bombing the neighbour's husky dog, and the raven is walking around in bare feet. They're so resourceful and they have a sense of humour in the face of adversity. There is so much I admire about ravens that I aspire to myself. They're monogamous as well. They live upwards of seventy-nine or eighty years. A lot of these Yukon turkeys walking around have been here longer than the people. They use tools, too. In mythology, they are equated with life and creation, the Creator. There are many stories of ravens throughout the culture . . . This is the Pacific Northwest. This is not Europe. The raven does not symbolize death, but life and creation all the way.

pj johnson
Whitehorse, YT

At the beginning of the world, the animals and birds weren't as we know them today. They had to go through a river of oil to get their final shape, and then pick up all their proper parts and colours. This is called the revelation of the animals.

"If the oil would flow sooner, it would be nice," said the raven.

What he meant was, the sooner the animals went through the oil, the sooner they would officially be those

animals. When the raven said that, the oil started to flow, and all the animals gathered there to go through the oil. The animals said out loud, "Oil is flowing," as each animal went through.

The bear was in a rush to go through, but the oil was still too hot. That's why today his oil doesn't harden, even when it is cold. When the man went through, he heard a cry nearby, and went there to check on who was crying. But it was only the fat rabbit.

The man said to him, "What's the matter with you?" The rabbit lifted his arms up and the oil drained from them and he hopped away.

Now it was time to give all the proper wings to the birds. The raven called all the birds together and said, "I'm going to be the big bird." He sat on the nicest wings and kept them for himself.

As he gave the proper wings to all the birds, the big birds' families said, "Somebody like him can't be a big bird like us." But the raven ignored them, and didn't pay any attention to anybody, as he proudly presented the wings to the birds.

Eventually there was a contest between the big birds and the raven for who was going to get the nicest wings. They had to fly to the rock to see who had the smoothest landing. The raven went first, and he flapped his wings as he landed. The next bird, who was going to be the big bird, had a smooth landing.

The raven said to the rusty blackbird, "Since I never had any meals from you, I'm going to give you short wings." So he did that. That's why today the blackbird has short wings.

The rusty blackbird said to the raven, "If you want to be the big bird, why don't you fly again to that rock?" And so, he did.

As he flew to the rock, the raven got hit with black ashes and the birds wrapped him up with a blanket and the men sat on him so he couldn't escape.

They said to the raven, "You will never be a big bird, and you will always be a raven."

The big bird, the one who had had the smoothest landing, claimed the nicest wings. They sent the raven back to finish his work of giving out the wings to the birds.

David Chocolate as told to Dorothy Carseen
Gameti, NT

Many, many years ago, when the world was new, God said to Noah, "There will be a great flood on this land. Everyone and every game will perish if they do not go in the big ship."

For many days, they had built a big ship. During this time, there were some people who were on their own and who had worshipped other gods.

The raven was the last one to board the big ship because he was eating the people who didn't board the ship.

Moses Koihok
Cambridge Bay, NU

Raven was a bird since Noah's time. Raven could understand Noah. Noah said, "You go and look for land." The Bible says he never showed up.

When Inuit people heard this story about Noah, one of our first grandfathers, they said they knew why he never showed up. They said his favourite food is the eye of any living being. He likes the eyes of people. People were floating and he was eating the eyes of people. That's why he never showed up.

He was one of the easiest ones to train. Raven was one of the smartest birds God created on earth. That's why Noah sent him. He could understand Noah.

Ishmael Alunik
Inuvik, NT

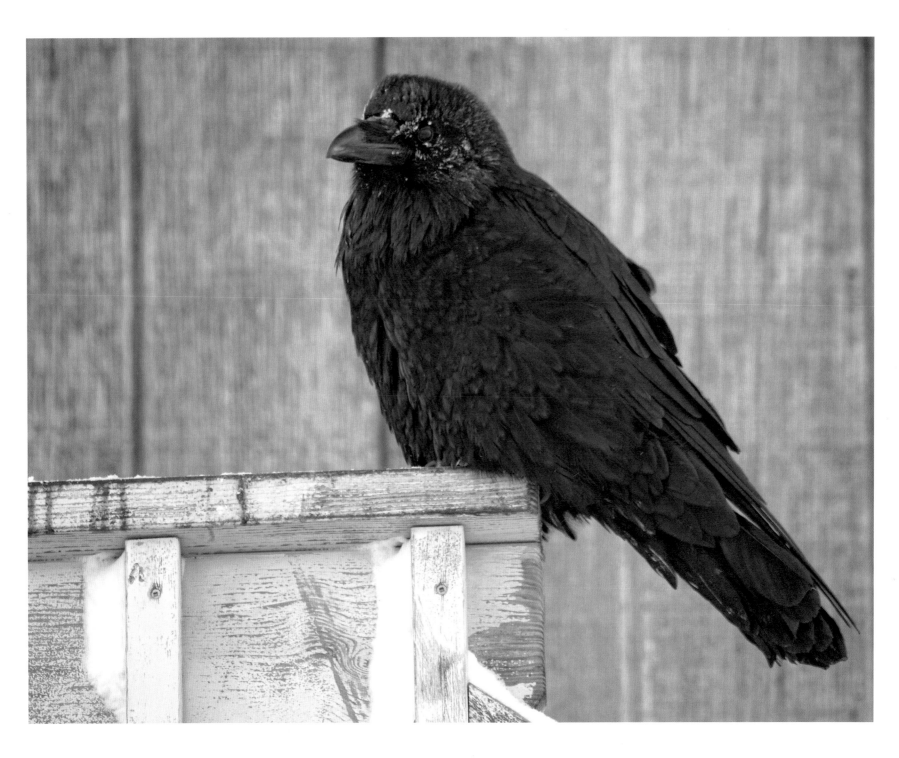

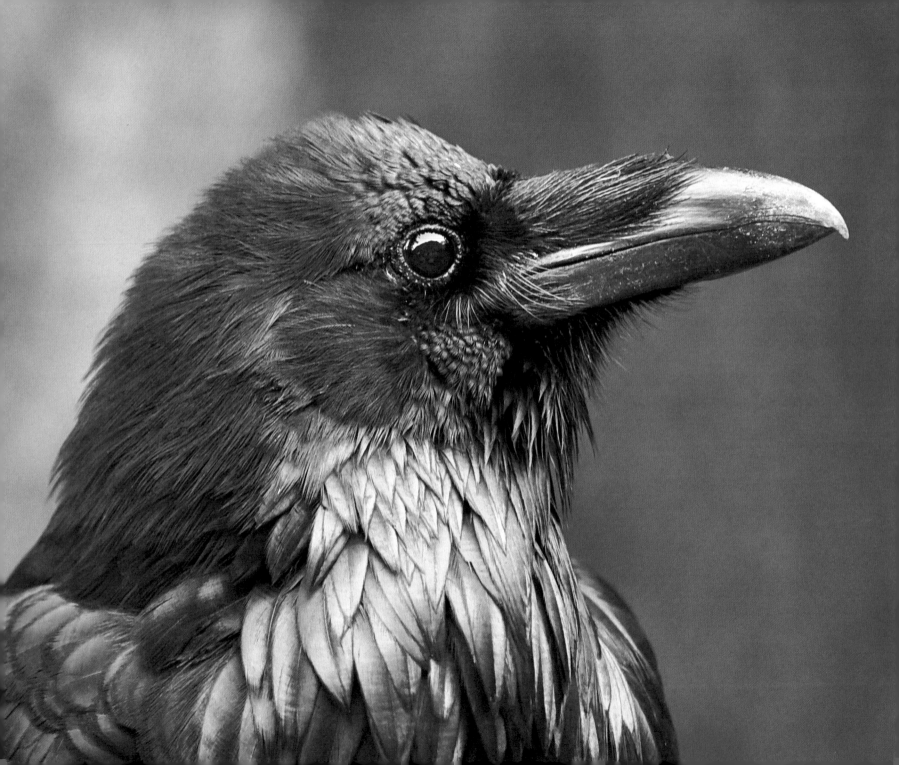

2.

Mythical and Legendary

I heard some of these stories from my grandfather, my grandfather's brother, and other Elders. I listened when I was very young. I listened to stories. Just like the other Inuit people, I never wrote them down because it was before schooling and some of them I learned before I knew how to write. They just stayed in my head.

Then this old feller, he was one of the smartest Alaskans. He migrated to Canada in the early 1900s before the missionaries came around. He had lots of stories. He always told folklore stories.

He just said, "I hope somebody will write down all the stories they learned when they were young." He said somebody should write these things, about how we lived so many hundreds of years ago.

These stories could be over 1,000 or 2,000 years old, even before Inuit came to North America.

Ishmael Alunik
Inuvik, NT

Our grandfathers, fathers, mothers, they told us stories. That is how we know the stories, and we do our best to interpret the stories as they told them.

When the raven used to be a person, he was the leader in his tribe. But when no one was around, he turned himself into a raven and flew around. Raven, he went away and appeared all of a sudden at the camp, where the people lived. No one knew that the raven had hidden a big herd of caribou in his camp. He made a big hole under the ground and covered the caribou with snow and only fed himself.

When he came around the camp, he was always in a cheerful and happy mood, while everybody was starving because there was no caribou or game. When he came again, people greeted him and showed him inside a tent. He left his grub bag on a branch. When the people looked inside the grub bag, they found some nice bits of caribou, the delicacies, like the tongue, eyes, and fat.

While the raven was in the tent, there was a big commotion outside about what to do with the raven. They decided to ask one of the ducks to follow him, with his medicine power. When the raven left with his grub bag, the duck followed him with his medicine power. The raven went southwest, intentionally, until he was out of sight of the camp. Then he disappeared into his tent, which was beside a huge hill. When the duck couldn't see clearly through

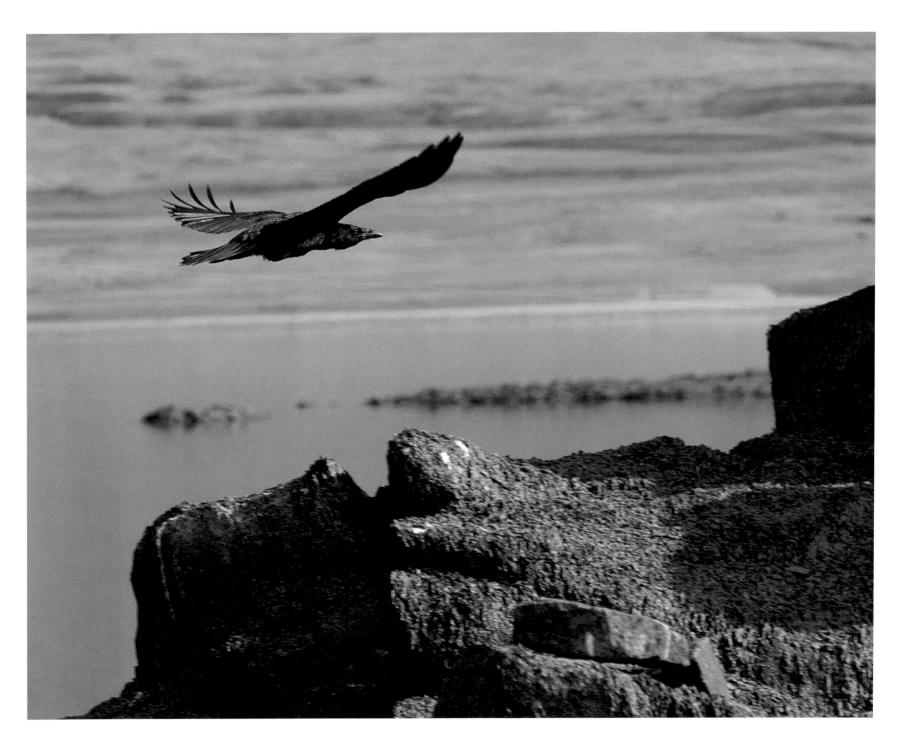

his medicine, he would say, "Please rub my eyes with ashes." The people would do that and then he could see clearly again.

The duck reported as to what he had witnessed and told them where the raven had gone. So the next day, the people went to the place the duck described and found the raven's camp. So they agreed that the wolverine, who was the smartest and fastest one, should go inside the raven's tent when it got dark. When it got dark, the wolverine went inside and crawled under the caribou hide and found himself underground with a big herd of caribou. That's how the raven was trying to fool his people.

When the caribou came out, the raven got trampled on and was nowhere to be seen. There were just tent poles left behind. Everyone was happy to live among the caribou again.

Then someone said, "I think we should give that raven a second chance." They asked an Elder lady who lived among them if she could bring back the raven.

She said, "Go to his place and bring me back his feathers and I'll sleep with them."

So they went to his place and gathered the raven's feathers and gave them to the old lady. She took the raven feathers and wrapped them up and put them inside her. She went to sleep, and the next morning the raven was sleeping with her.

That's how the raven came back. His uncle, the wolf, said to him, "As long as you live, from now on, you will not kill anything to eat." He said, as he got mad at him, "You shall eat garbage as long as you live."

And the raven has flown around and picked on garbage ever since.

David Chocolate as told to Dorothy Carseen
Gameti, NT

This story is from my mother. Her grandmother told her stories most of the time. She said ravens are gifted.

In the wintertime, there was a family travelling. They knew they were supposed to go on the land where the caribou were migrating. They travelled to their destination. They arrived at the place where there was migration most of the time. When they arrived there, they were very hungry. This young man had a wife and a lot of young children. They were hungry when they arrived there. They didn't hear a sound, not a noise, so they knew there were no animals.

They kept going.

All of a sudden, the husband said, "I better go hunting."

The wife agreed, because they were getting hungry and the children were getting hungry, too. The husband went hunting all day long. It was late at night when he came back. He came back with nothing. The children were hungry and they were upset. They were crying. Early the next morning, he went out again. This time, the family was very, very hungry. In those days, people only lived on dry meat and dry fish, or fresh fish or fresh meat. That's all they had in those days. There was no ptarmigan, nothing in the winter. They were dependent on big game.

He went out hunting again. He came back with nothing again.

Early the next morning, he told his wife, "I can't go hunting again because I don't see anything. I don't see any tracks. I am going to make a hole in the ice. Maybe there are some fish in this lake."

As he was making a hole in the ice, all of a sudden, a raven came. He heard a noise and it was a raven singing away. The raven flew around him three times and then he headed in one direction. The man ignored it and kept trying to make the hole in the ice. Again this raven came back and circled him. His wife heard the raven.

His wife said, "Husband, follow that raven. He is telling us something. Follow him."

So the husband obeyed his wife. He took his bow and arrow and followed him. When they got to the top of the hill, they sat on top of a tree. He saw a bunch of caribou far away, going in a different direction from him. This time the raven really, really cried out and made that funny, ugly sound, but it was the most beautiful sound the man had ever heard. As soon as the raven started crying, those caribou turned in a different direction, moving toward them. The husband was very, very happy. He killed enough caribou to feed the family. He went home and brought the meat to his family, and the caribou hide. So, the wife was very, very happy and the children were very, very happy. They ate.

My mother said her grandmother told her that caribou gave us enough hide to clothe ourselves for the winter, for *mukluks*, parkas, and clothing, and enough meat to make dry meat. They gave us enough caribou hide for blankets, too. This is how the raven saved the starving people. This is a legend my mother told me. That story has been with me for a long, long time.

Muriel Betsina
Ndilo, NT

There is a story I can tell about the pregnant dog and the pregnant woman.

It is said the people left them behind when everyone else was moving. She gave birth to a child and she used the placenta on top of the iglu to lure the ravens. That is how they survived, by catching ravens as food. Her child grew up having ravens as food.

When the boy was getting bigger, she put a raven beak as the tip of his hood. When the boy grew up, the people who left them behind came back to kill them. His dog team understood everything, and of course they had no guns at all. They just had a bow and arrows. He would use his bow and arrow to kill off the people who came to kill them. Even if they were far away, he could see the arrow heading straight for the person.

The boy said to the dog team, "If anyone tries to attack me, let my lead dog know."

When the people saw the boy, they started attacking him with arrows. When the arrows started toward him, he would catch them and break them in half. One arrow hit his hood where the raven beak was and it made a "Qra" noise. "Qraaq," a noise just like a raven would make. Again the raven beak called out, "Qraaq."

His lead dog came across all the arrows that were heading toward them. He would jump and his head would spin to catch the arrows. That was how he was breaking the arrows, by catching them. The boy with the beak of a raven on his hood was near the lake where the people, moments before, were selecting skins and saying, "This skin will become my parka. This skin will become my pants. This skin will become my winter pants."

When the boy who had a raven beak on his hood would fling an arrow with his bow, it would go right through the person, and that was how he killed off all the men.

Just moments before, all the women near that lake were singing, and they were still singing when he approached them. He told them, "You no longer have anything to sing about. Stop singing now."

Again he yelled out, "You no longer have a thing to sing about. Stop singing now!"

When he stopped yelling, all the women were crying instead. Because he killed off all the men, he became responsible for looking after all the women and their families. He promised to look after them and asked to take them home. There must have been quite a lot of people, but he took them home.

The mother was the only teacher to her boy, because they had been left behind. When the mother was teaching the boy to use the bow and arrow, she would instruct him to throw his mitten in the air and just aim for the thumb of the mitten. Of course, when he started practicing, he would make a hole in the middle of the mitten first, but soon enough he was getting better and more accurate. He started making a hole just in the thumb. That was when the mother told the son he could attack the people who had left them behind.

That is how the story goes.

Atagutak Ipeelie
Arctic Bay, NU

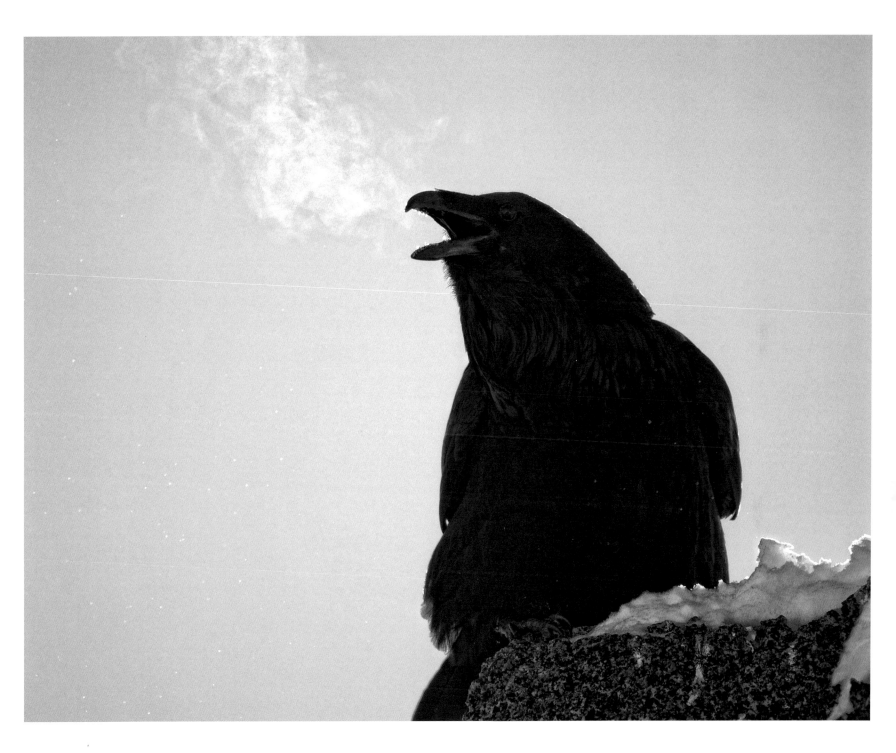

Another prospector and I were out to stake a group of claims. It was in February or March. We were in the trees and it was cold, -30°C to -40°C. Some days, we were out working together on one line, some days we were by ourselves. One day, I was out by myself blazing a line over a hill. Sitting on a dead jack pine not far off the line was a raven. It was as if he or she was sitting there waiting for me to come by. As I approached the raven it started talking, so I talked back. We discussed the weather, which was cold. As I moved along, putting in the claim line, the raven would follow along from tree to tree. That raven stayed with me for most of the day, talking all the while. Several times during the job the raven would come for a visit, but only when I was out working by myself. I asked the other staker if he saw any ravens and his answer was, "Nope," so somehow that raven and I had a bond. If you believe in reincarnation, I reckon it was a long-lost friend coming back for a visit.

Walt Humphries
Yellowknife, NT

It was almost a relief to see them sometimes, when you'd been travelling for two or three days. We were coming back from Pangnirtung one time, and a raven flew over after three days. You'd think, "There's something else alive out here. I guess the world didn't end while we were in the mountains." I made a connection with them that way and felt better about the world. They're puzzling, because they're curious. When they would fly by, you were looking at them, but they were equally looking at you. It wasn't magical or mysterious. It was just a connection with something that was alive.

T. Bert Rose
Iqaluit, NU

The crow and the raven are identical. One time, this crow wasn't a crow like we see today. My mother told me about this. She learned it from her grandmother's legend.

 This crow was such a beautiful, beautiful, beautiful, beautiful bird. He had a beautiful sound. He was so

beautiful among all the birds that he made slaves of all the pretty birds. He didn't want any birds to be as pretty as he was. He had a beautiful sound and could sing. As soon as his voice opened, all the birds worshipped that beautiful bird. As each day came, he demanded more. He was demanding other birds listen to him and serve him and look after him and bring him food. He was getting fussy and very proud: "I don't want that food. Give me other food. Give me another plate. I'm not satisfied with this plate."

All the servants went out and were doing all the heavy work for this beautiful bird. One bird got hurt. It wasn't a very pretty bird, but it was a servant to this pretty bird. This bird had a broken leg and was hopping. The pretty bird was being demanding of this bird with the broken leg.

This bird, in a humble way, put a spell of witchcraft on the bird with the broken leg and said, "From now on, nobody will ever talk back to this little bird that was not very pretty and had a broken leg and was crippled and couldn't do the work."

The bird with the broken leg turned to this pretty bird and told him, "From now on, your voice is not going to be pretty. Your voice is going to be the ugliest sound that a bird ever heard. And you're not going to be pretty anymore. You'll be the blackest, blackest, blackest bird and your beak is not going to be pretty anymore. Your beak is going to be curved and will have a hump. You'll have the blackest, blackest eyes. Even in the dark nobody will know you except for this ugly sound because that's how ugly you're going to be."

This is a lesson for us. My mother said never be proud. We always have to be humble and look after our Elders.

Muriel Betsina
Ndilo, NT

My dad tells a story: One time, he was in Labrador. He said someone split a raven's tongue in half so it could curl its tongue. They said it could talk if you did that.

Bob Lyall
Taloyoak, NU

This is a Dene legend my mother told us when we were very, very young. It was from her parents and grandparents. Many years ago, all the young people would come to the Elders' tent very early, and they would always tell stories. This is one of the legends my great-grandmother heard. It's about a moosehide.

This grandmother was very tired . . . All day long she sewed clothing for her people. She made a bunch of moccasins out of moosehide for her children and her grandchildren. She had a habit of working hard. She made a bunch of dried meat out of moose meat. Then, she had to fix this moosehide. She was not very young anymore. She was pretty old, and most of the young people around her were out hunting, fishing. They went all over the place. There was a moosehide she was scraping. She was tired and she fell asleep on the moosehide.

All of a sudden, there were three or four ravens moving their beaks and fixing the moosehide. She'd glance at the moosehide and see the ravens. Slowly, she fell back asleep.

The ravens told her, "Grandma, you just sleep. We'll do the moosehide for you. You just go to sleep." She fell right back asleep.

They made a bed for her out of spruce boughs so the grandma could sleep well. They piled up some of the spruce boughs so she could sleep comfortably. Again she woke up. This time she didn't see ravens. She saw four young women.

These young women told her, "Grandma, just sleep. We'll finish your moosehide for you. Just go to sleep." The grandmother fell asleep right away again.

She woke up again and the moosehide was all done and shaken and hung over a stick. It was just waving. She glanced at those four women again and they told her, "Just go to sleep. We'll fix the moosehide for you." Again she fell asleep.

The next thing you know, they smoked her moosehide. She smelled the smoke and her moosehide was all done and hanging up. She thanked those young women for helping her. Those women told her, "We finished looking after you. We fixed the moosehide for you." In no time, they turned into ravens again and flew away. This was the first time and the last time anyone ever made a moosehide in one day, in twenty-four hours.

That's one of the legends my mother told me that her grandmother told her.

Muriel Betsina
Ndilo, NT

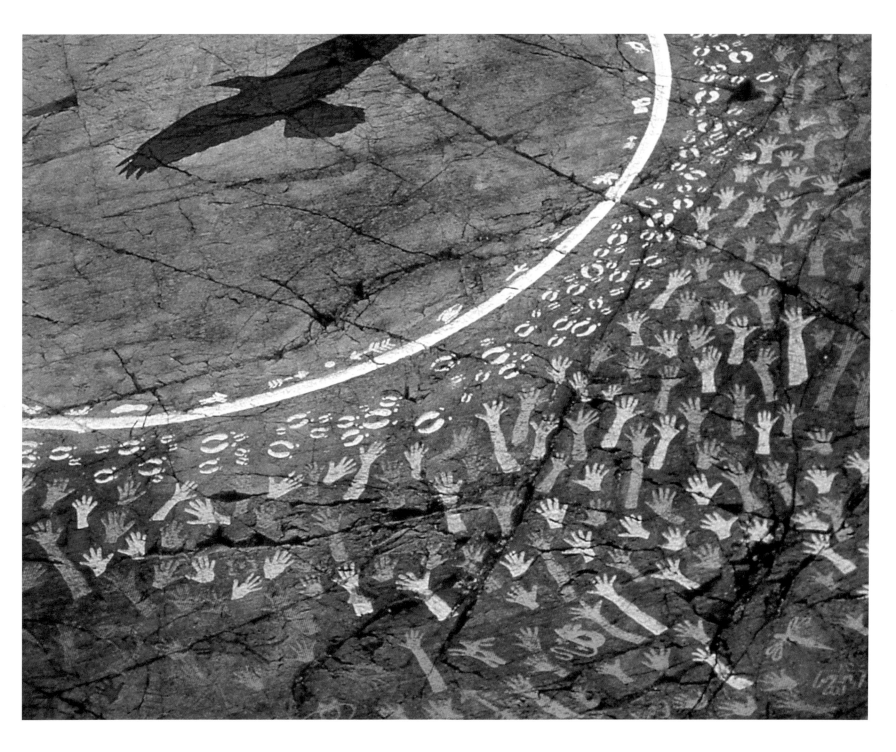

I will tell you a story.
Long ago, those repulsive ravens could talk. A person asked a raven that was flying high above, "Big raven high above, have you seen my nice little needle?"

"Qa qaaq, qa qaaq."

"Where is it? Where is it?"

"It is where the dogs curl up, that is where it is, jaiiiii. I see the big vertical eye."

The needle had found its way to where the dogs curl up during the winter months and that is where the lost needle was found.

That is how things were.

Annie Tiglik
Iqaluit, NU

From my knowledge, there was a belief that ravens bring luck. When they are crowing while flying, it means there is something out there. When that happened, I even believed it myself. We come from another region, I am not originally from here, and when they do that, we call it *kiguaraq*.

One of the songs that I myself call *pisiit*, ayaya songs, goes like this:

The big raven is signalling by,
going sideways and cawing up above in the skies.
I believe it so. I will go see what's there,
certainly there, deep in the valley is the herd.

The big raven knows that the caribou herd is there. That is the end of the story.

Celestine Erkidjuk
Iqaluit, NU

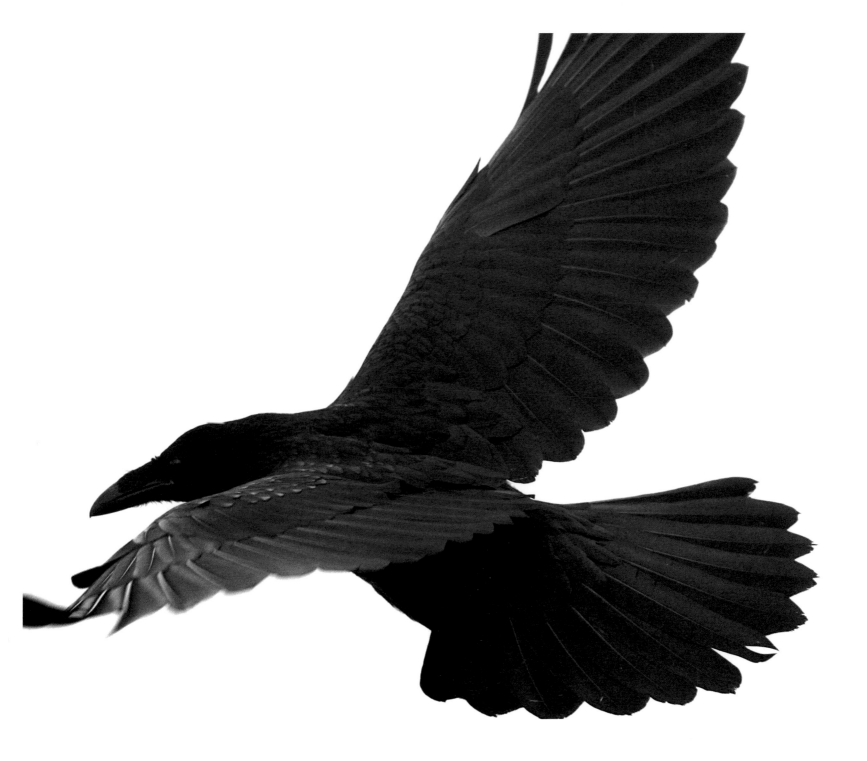

There's a funny story about ravens. I don't know if it's true or not, but I'm going to tell you anyway.

I don't know if it was by shamanism or not, but a raven could turn himself into a baby. He wanted to become a human being. There was one young girl; she was one of the chief's daughters. She never wanted to marry anybody. She never found a man she really liked. She was a virgin.

Her father was telling her, "There's a great hunter there. There's a great hunter there. There's a great hunter there." But she said no, she didn't want to marry anybody.

A raven heard about it and said that the only way he could make her pregnant was to make himself into a little speck of dirt, or something else that a fella can't see, in the drinking water. The virgin always went down to the stream and got cold water in the morning.

One day, the raven turned himself into the smallest little thing that you could hardly see. The girl swallowed him without knowing it and he ended up in her womb.

She started to get pregnant. Her dad asked her how she got pregnant, not knowing a man. She said she didn't know.

That's a silly story.

Ishmael Alunik
Inuvik, NT

Here is a story about a raven that had a seagull for a son-in-law way back when animals turned into humans.

The ravens were picking at dog feces, trying to eat them, because this is what they ate. The raven encouraged his son-in-law, the seagull, to eat dog feces, but the seagull refused. The seagull became hungry and cold and huddled among ice drifts.

The raven would say, "*Quniqtuq qunuqtuttiaq,*" referring to his son-in-law, the seagull. He would say, "My son-in-law is always huddling, I will call him the huddler, the great huddler."

The seagull finally replied to his father-in-law, the raven, "*Upingarmikpat sakiiiiiik kakivaatiavut tiguuqarlutigut*

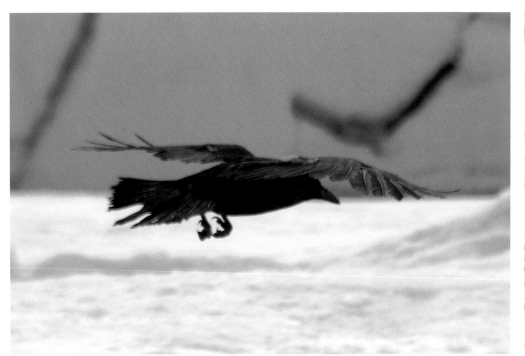
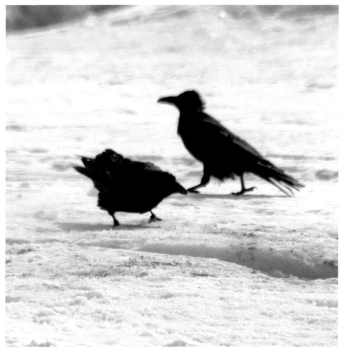
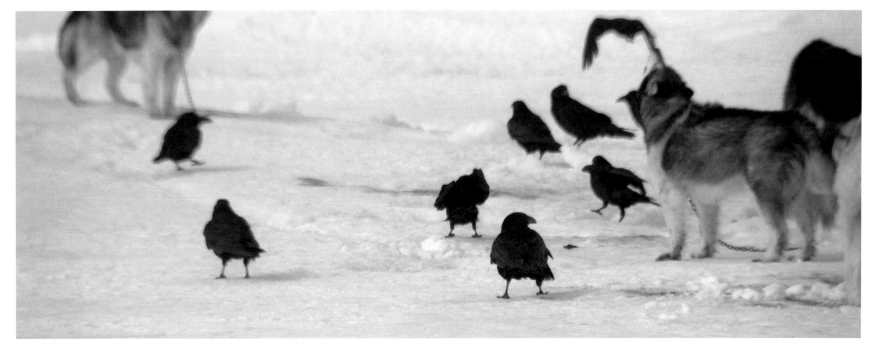

maani saputini piqattalirmigutik naujat timittiattini qaa-qaarjuaqpalirmiguvit tusarniirsarjuaqpalaarmivutit. Just you wait, my in-law! When spring comes, and fishing with spears in the weirs resumes, and seagulls start to feast on the leftover fish, all you will be doing is calling out, 'Qaa, qaa.' Make sure it sounds good!"

Atagutak Ipeelie
Arctic Bay, NU

This is the only story of the raven and the seagull that I can remember.
They are both known to be hunters.
The seagull told the raven, "All you do is call out 'qaa, qaa' when we are feeding."
The raven kept saying to the seagull, "All our brother-in-law ever does is huddle in the snowdrift because he is very cold."
What they mean when they say huddling is that they stay in one place because they are too cold to do anything else. That is what they mean when they say "*Quniq.*"

Qaapik Attagutsiak
Arctic Bay, NU

This is the only legend I know. I heard about the seagull and the raven, many years ago.
The raven said to the seagull, "During the coldest days of the year, I can outlive you."
The seagull replied, "When the creeks are opening again, I can use my *kakivak* to spear the biggest fish, using my beak, which you cannot."
This was so, because the seagulls were known to catch fish and they could stay by the fishing nets for a long period of time until the fish were caught. This I have seen the seagulls do so they can eat the caught fish. This is all I have heard. I remember this from an Elder.

Mackie Kaosoni
Cambridge Bay, NU

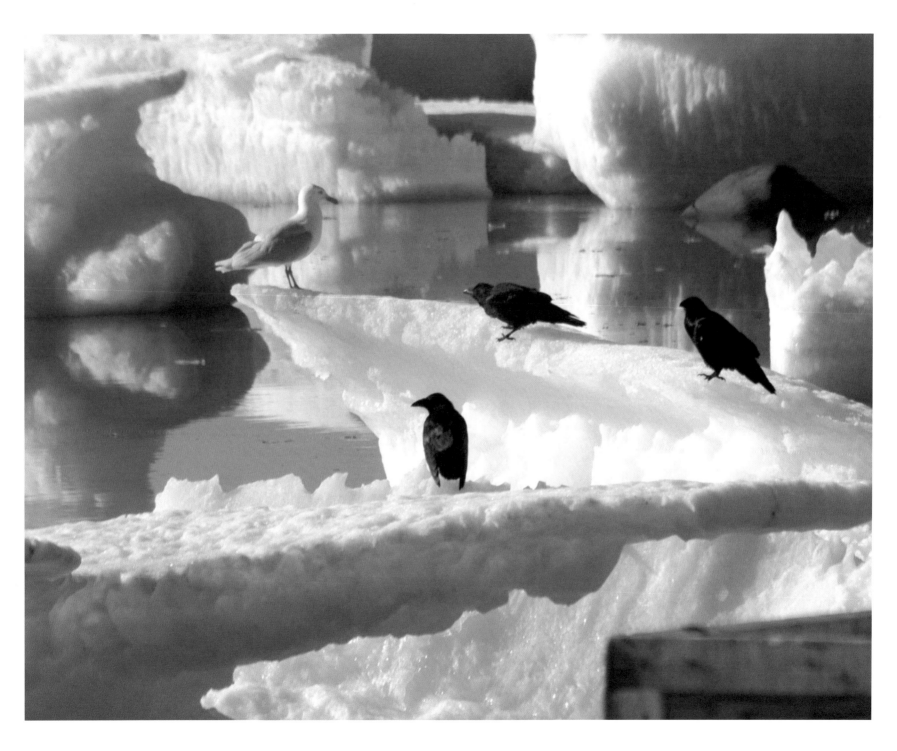

The raven, according to the First Nations' stories, he had some sort of super powers. He could turn into a human being. He was raised up by his grandmother. He grew up to be a hunter, but he was a lazy one. He got a really pretty wife and he had to support her. He told his wife to make mukluks. He was going to walk all day. His wife made brand new mukluks so the soles could last all day if he was going to walk through rocks.

He came back with nothing. He said, "Look at my shoes, they're worn out and I never found anything."

Bearded seal skin is hard to wear out. It would take about two weeks to wear out. I used them myself when I was young and we'd walk.

Again he came back with nothing and his shoes were all worn out and he said, "I never found anything." He said, "My wife, I am so tired."

Somehow she got suspicious about her husband. She could never see where he was, so she kind of spied on him. Finally, there was a raven sitting down on the rough rocks, rubbing his shoes off. He wore them out.

The story goes that she kicked him out.

Ishmael Alunik
Inuvik, NT

There was a bunch of people travelling to another place, to another campsite or hunting ground. It was way up on a hill. The raven really started calling and singing a song, calling to them, asking if any of the people wanted a son-in-law.

"Hey, you folks down there. In the storm, in the wind, I will fetch your water," the raven called.

An Inuk replied, "You are no good for a son-in-law. You always eat shit."

The first travellers passed by the raven. As you know, travellers never travelled all together, but in small groups, one in front of the other.

When the second group came, the raven yelled, "Hey, you folks down there, take me for a son-in-law. In the storm, in the wind, I will fetch your water."

An Inuk replied, "You are no good for a son-in-law. You always eat shit."

The raven looked away in disappointment. Soon the third party of travellers was passing by and the raven repeated what he had said to the others, "Hey, you folks down there. In the storm, in the wind, I will fetch your water."

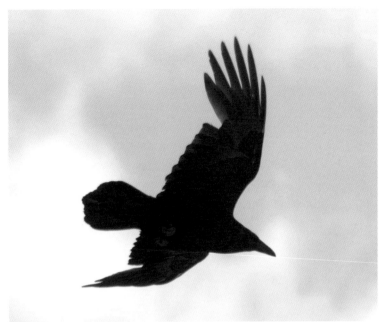

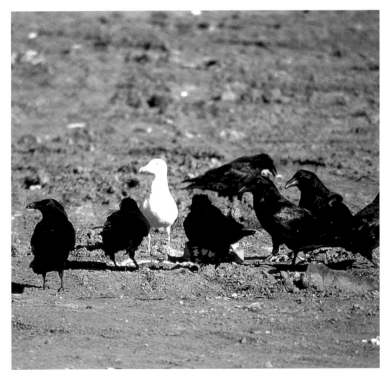

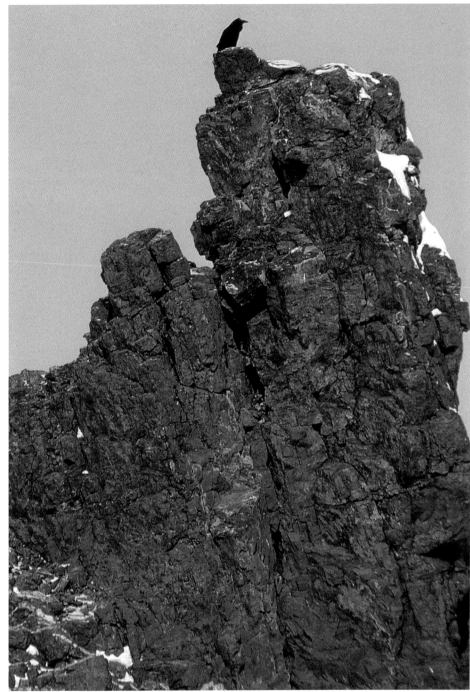

An Inuk replied, "Yes, come here. Come be my son-in-law, as I have a daughter ready for marriage."

The raven then went to greet the Inuit after being accepted for his chanting. The Inuit waited for him. The raven became the image of a human and then became the man's son-in-law.

The family was often very grateful for the hard work that the raven did for them. The mother-in-law had left a small piece of her last caribou hide out to dry. She was about to make a small pair of mittens with her last piece of caribou hide. The weather was blowing snow. New tracks can be made in new snow. The raven had been chewing on the hide, rather than working on his chores. The raven chewed the hide until it was very small. The mother-in-law went to get her hide and found that it had been chewed until it was a useless piece of hide. She noticed the tracks in the snow and soon realized that the person who chewed the hide only had three toes. This made her very angry.

Soon there was to be a gathering of all the villagers in the large celebration house. Here she told of her chewed-up hide and asked everyone to sit, asking her son-in-law to sit at the very end. Soon after everyone was seated, she began to remove their footwear, inspecting their number of toes. As she neared her son-in-law, he became restless. He was soon asked to remove his kamik and exposed his three-toed foot. The mother-in-law began beating her son-in-law. She struck him in the arm, which was his wing. While she was beating her son-in-law, she broke his wing. She began to spin him around on the floor. The friction began to make a hole like a fishing hole in the ice. That was how the entrance to the house was made. She then threw him out the entrance.

When the daughter arrived home, she waited for her husband to come home. He did not return home. When she proceeded outside, she noticed blood drippings and soon began to follow the blood and the tracks. She had begun to really like her husband. She tracked him for a long time and soon she reached him. The daughter had many amulets that she wore. She wanted to bring him home to their house, but he refused. His arm was broken. He refused to go home with her because his mother-in-law did not like him for what he did to her hide. He instructed her to return home without him.

Lilly Angnahiak Klengenberg
Kugluktuk, NU

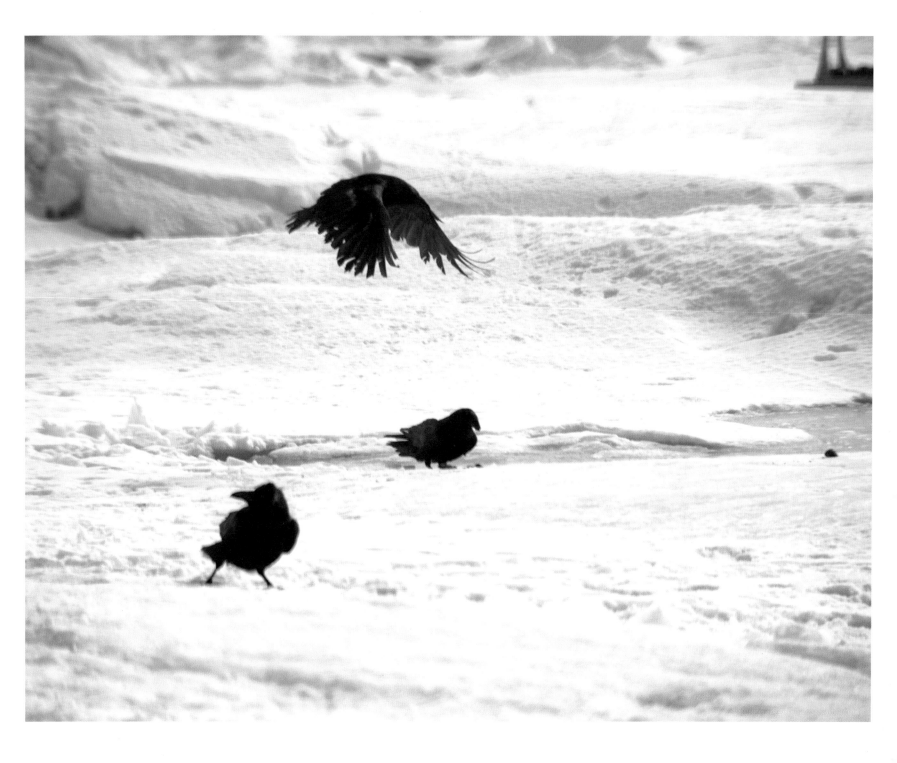

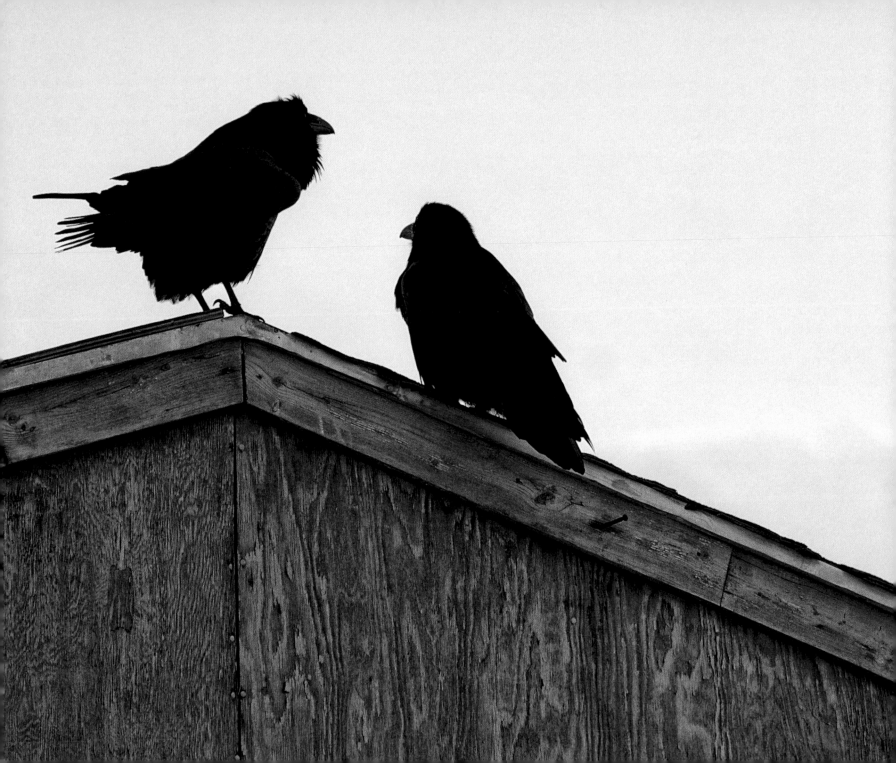

3.

Trickster

This is the weirdest thing we've seen them do since moving here. Up at the top of the open valley here there is a fairly steep hill. Almost every year, after a storm, we see ravens climbing up the hill from the bottom—climbing, not flying—and getting up to the top. They look around to make sure nobody is watching, and then tuck their feet up and slide down the hill on their bellies. We see children doing that. We see lots of kids playing on the hill in their toboggans. Seeing ravens doing exactly the same thing kind of throws you off.

T. Bert Rose
Iqaluit, NU

It is said that ravens can talk.

When I am walking all alone and I think maybe the raven is an orphan, like me, it seems to be saying, "Me and you, you and me."

Sometimes they say things that a person can understand.

Inusiq Davidee
Iqaluit, NU

The raven used to like to lie. But he was the only one that could fly, and the eldest, too, so if anyone wanted advice, they always said, "Ask the raven, he's the Elder."

When the people killed a bear, they asked the raven, "What do we do with the bladder?"

He said, lying, "You put the bladder at the river and when you cook the fat, put the fat in the bladder."

The people believed him and did what he said. They cooked the fat and put it in the bladder at the river.

The raven said, "I have the runs," as he went down to the river. But he was really down at the river to eat the fat.

Elizabeth Chocolate as told to Dorothy Carseen
Gameti, NT

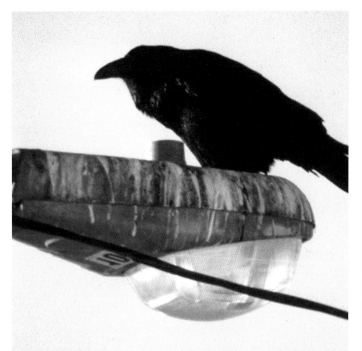
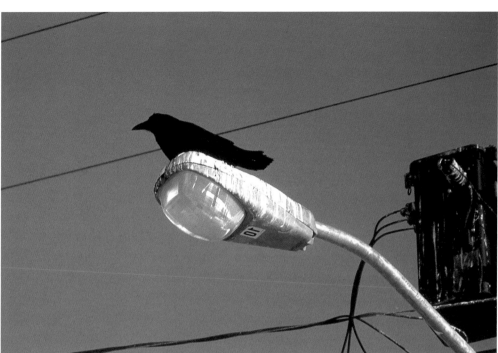
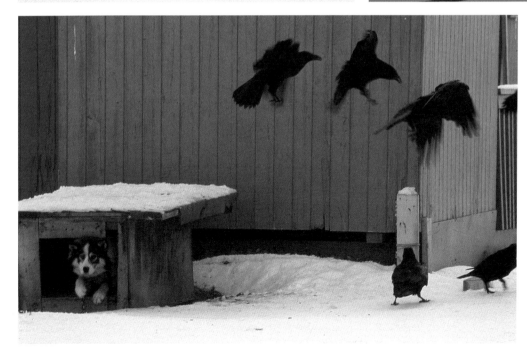
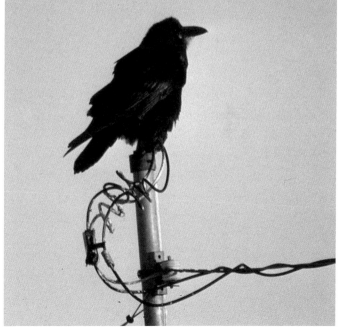

It was spring, and it was nice out, and I was heading out of the office for lunch. Our cable television head end, which services all of Yellowknife with all of the cable TV channels, is located in a shed behind the building where we worked. The power poles supplied power to this. In the event that you lose power to your cable television head end, all cable television goes down for the city of Yellowknife.

I was one of those skeptical people who heard about power outages caused by ravens. I was always the first one to say, "Ya, right, ravens." One day, I went out for lunch and there was a raven on the power line in the parking lot close to the head end. And all of a sudden here was just the biggest bang and this raven went flying off the transformer and feathers went flying. It disappeared. I don't know if it died, but it got zapped, big time.

I could see black smoke around the transformer. I had to go tell everyone in the office about this. I came back into the office and the phones were going mad. The customer service representative said, "You have to help answer the phone. The cable is down and we don't know what's wrong. All of Yellowknife seems to be out."

The transformer blew the power supply to the head end. The first thing I did was get on the phone to the power company and explain what I had seen and what the end result was. I started answering the phone, and I was explaining the great extravaganza I experienced and, lo and behold, I got a cynical response. The culprits got us again!

Cathie Bolstad
Yellowknife, NT

There was a man who went out caribou hunting. When he started cutting the caribou, he threw away some parts he didn't want and there was a raven that said, "Tuktu, tuktu."

The hunter gave some bits of meat to the raven and, before he knew what had happened, the hunter gave all the meat to the raven and didn't have any meat for himself. The raven kept on begging until there was nothing left for the hunter, and in that way he fooled the hunter.

Enuapik Sagiaqtuq
Iqaluit, NU

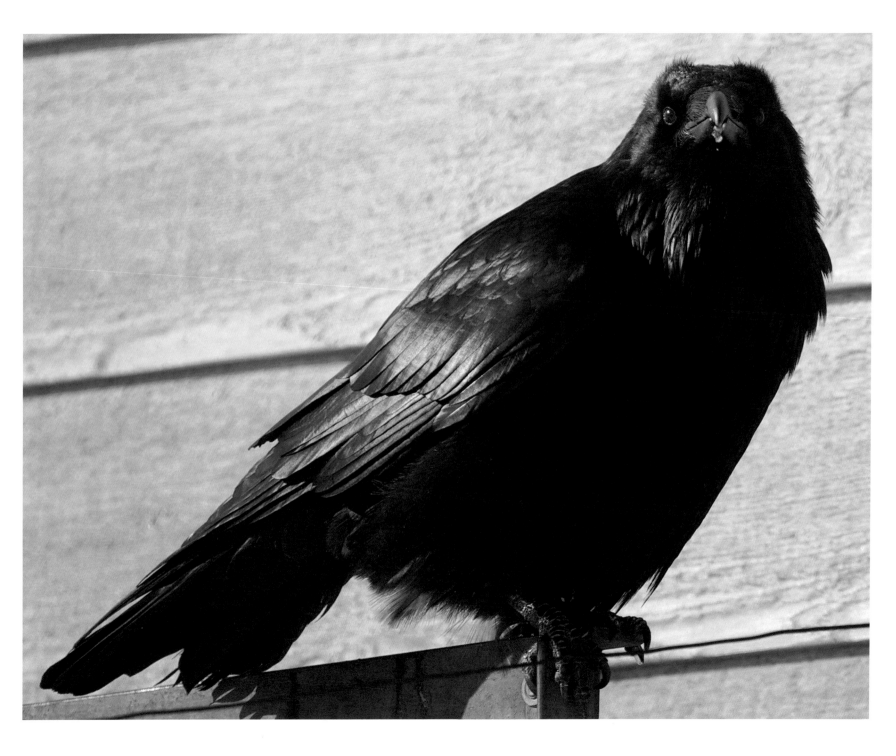

I was living in co-op housing at the time. The house we stayed at is attached to another house. Ravens used to always come and sit on our side of the house. They never sat on the other side of the house. Our side was always covered in raven shit and you could hear them jumping on the roof.

One time I was going out. It was August. I called a cab and I was standing outside the door. Pualuq, the dog, came around to see me and went down the stairs. She was sniffing around and was going to pee. All of a sudden I heard this barking, and it wasn't coming from the dog. I looked up and there was a raven barking at the dog. That was the only time I heard it. It sounded exactly like a dog.

When we were living down on Federal Road, my sister had a puppy. The ravens used to come and take bones and drop them on the puppy. What we never figured out was if the ravens were bringing bones to the puppy out of the sweetness of their hearts, or if they were trying to kill the puppy.

Lucie Idlout
Iqaluit, NU

The story goes like this: Long ago, a group of people that were in hunger were cooking outside, boiling lichen. Lichen can be cooked to make stew. There was some lichen left to boil, so a woman started singing, "We have been making lichen all day long, and our bedding is gone."

The woman sang that song, and a raven came and soared above them and started talking to them. "*Qawq, pikuk, pikuk, tuktuktuktuk punniirnik marunik marunik marunik,*" it said. Meaning, "Caribou, caribou, caribou, bulls, bulls, two, two, two."

The raven was saying that, so the husband looked at the wife right away and told her they had to go collect lichen.

He told her, "Pikuk, the raven caught two big bulls."

They were overjoyed. But it was two little lemmings, two little lemmings that the raven said were two big bulls. And that is how the legend was told.

Naki Ekho
Iqaluit, NU

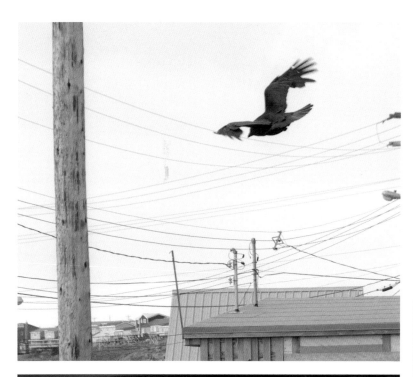

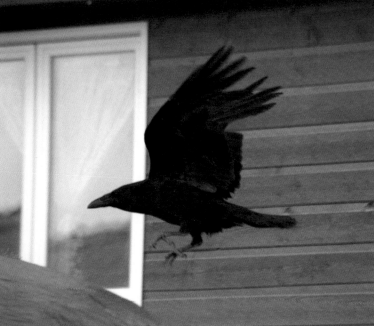

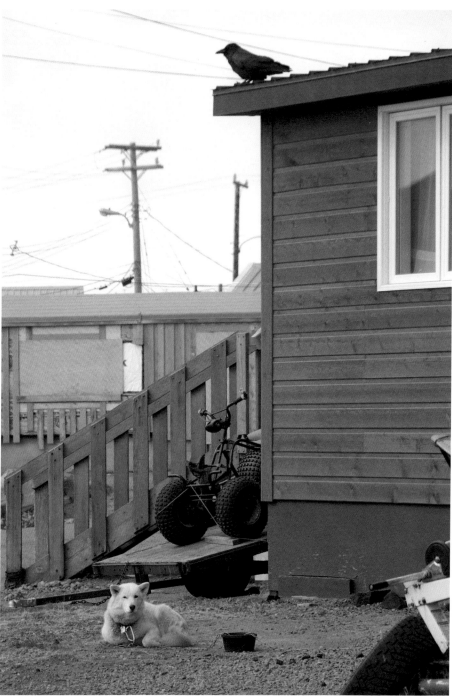

In Whitehorse, the ravens put their wings over the streetlights during the day so it goes dark and the light comes on and the heat develops. They hang out there.

Hans Nelles
Haines Junction, YT

When we moved here to Iqaluit in the early 1980s, we were initially down in the centre of town and we didn't see a lot of ravens. When we moved here to this house, in 1983, this was the only house in this spot and there was nothing beyond here. The houses across the street were still under construction. There were ravens here that were relatively undisturbed by traffic going back and forth to Apex. We began to watch out the windows. We would watch them on the pole. We saw them playing.

The first thing we saw them doing was playing chase along the wire. There would be three of them and they would move down the wire, taking turns hopping down the wire and seeing who would get to the pole first, and then they would all fly away. Twenty minutes later, they would come back and do the same thing again. Sometimes we saw them do that in the fall, sometimes in the winter, in the spring, the summer. There didn't seem to be a mating thing going on, just having fun.

Along the same wire, in the same area, we sat in the living room and we watched two ravens. One was sitting on a pole watching the other one. The other one was in the middle of the wire turning somersaults. It was very deliberately perching on top of the wire, squawking and clawing a little bit and doing this somersault thing around the wire. It was showing off.

T. Bert Rose
Iqaluit, NU

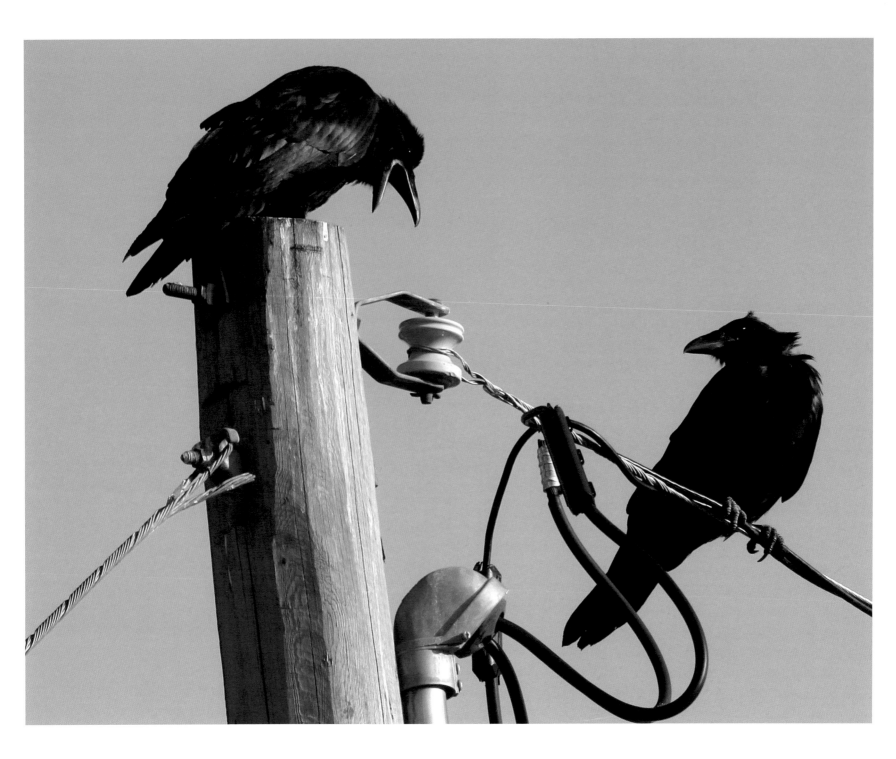

The story goes that every spring, after the ravens have started to raise their young, they come out to the golf course and lie in wait in the landing areas on some of the par fours. After everyone has teed off, one or sometimes two ravens will swoop down and pick up a ball and play with it a little while until you get in range. Then they'll pick it up and fly away. It's been going on the last forty-five years.

I figure when the manager at the time was looking for a logo, they thought the raven would be the best logo. The ravens have been doing it ever since I started golfing, which has been the last twelve years. I've lost probably two balls a year to the ravens. It's usually on the fifteenth hole, when they know I'm coming and they're waiting in the trees. Whenever we get new members and we're sitting around the clubhouse, they'll tell the story.

We're not sure where the ravens store the balls. We've never found a large stockpile. People have seen golf balls in the middle of downtown Yellowknife, and out at some of the different recreational lakes. We're not sure if people are just taking balls or whether the ravens are flying and dropping them. They do the same thing at our driving range. It's costing us quite a bit of money every year. We buy boxes of balls. There are probably 1,000 balls in every box. We lose a few balls to the sand, but the ravens are continually coming every morning and taking the balls and flying away. We go through quite a few dozen balls because of these guys. I don't mind so much. It adds local character to our course, and we're using their image on our logo, so it's a small price to pay. People don't get upset because there is a rule in golf that if an outside agency moves your ball or takes your ball you get to place it at the nearest spot you thought it was and continue playing. It doesn't cost you a stroke. Most members don't mind . . . It's a local hazard.

Arnold Enge
Yellowknife, NT

My house is situated down by the graveyard and it's a good perching spot for ravens, as it's right above the beach. They were causing a lot of nuisance. There were droppings on the house and they were bothering my dog and making a lot of noise, so I got myself one of these owl decoys they use in the south. I put it on my roof and I put it on a tree branch and stuck it on my house. For about the first year it worked and was pretty effective and kept the ravens off the house, but after that, the ravens figured, "The sucker should have moved by now." It was always facing the same spot and never moving.

After a while, I noticed they started sitting beside it and squawking at it. After that they started leaving a lot of

droppings on the owl and dive-bombing it. Eventually, they'd sit right beside it and started landing on it and pecking at it. They pecked a big hole on the side of its neck.

I thought I'd try one more thing, so I climbed up on the roof and turned the owl in a different direction. That seemed to work for a couple of months, but it was right back to the old thing. It got to the point where the owl was attracting the ravens, and they were all coming to see the owl. My roof was turning white from droppings. I decided to take the owl off, and when I did I noticed that it was making rattling sounds. I could see through the hole in the neck that the ravens had made while pecking at it, so I shook it and saw that there were lots of objects in there. Lots of shiny things, like necklaces, and plastic flowers from the graveyard, and beads and trinkets. I shook them out, and I was interested in why the ravens would drop those ornamental things inside the owl. The best I could figure is that they were using it as a storage place, or they were trying to make it move again. Stupid owl.

Larry Simpson
Iqaluit, NU

A hunter was out hunting and a big raven told him that he had caught a caribou. The hunter's family started throwing out the food that was not fresh anymore because the big raven had told them that the hunter had caught caribou.

"Tuttutu tuttutu."

When it said that, they started tossing the caribou meat and the food into the garbage. But it was a lie; unfortunately, he did not catch any caribou. They did not have any food, since the raven had deceived them.

Enuapik Sagiaqtuq
Iqaluit, NU

I was having coffee at the Gold Range coffee shop one morning in the summer and sitting by the window facing the Centre Square Mall. We noticed a raven sitting on the ledge of the building above the Bank of Montreal. I noticed that it had some stones or something on the ledge, and every time someone would walk below it on the paved sidewalk, it would drop something on their heads. People would look up, but the raven would walk back and hide so people wouldn't see it. The people couldn't figure out what hit them or who was throwing things at them.

Mikle Langehan
Yellowknife, NT

There are some cliffs over by Jackfish Lake. When the wind blows across the lake, there is a big updraft created. All the ravens congregate there and do acrobatics. I've seen one who brought a piece of toast. All the ravens would chase him, and when he dropped it one guy would go down and pick up the piece of toast and be "it." It would start all over again. It was a lot of fun. They're great fliers and very acrobatic. They do the same thing in Yellowknife from various buildings. You see them playing tag. It's great entertainment and it takes your mind off work for a little while.

Arnold Enge
Yellowknife, NT

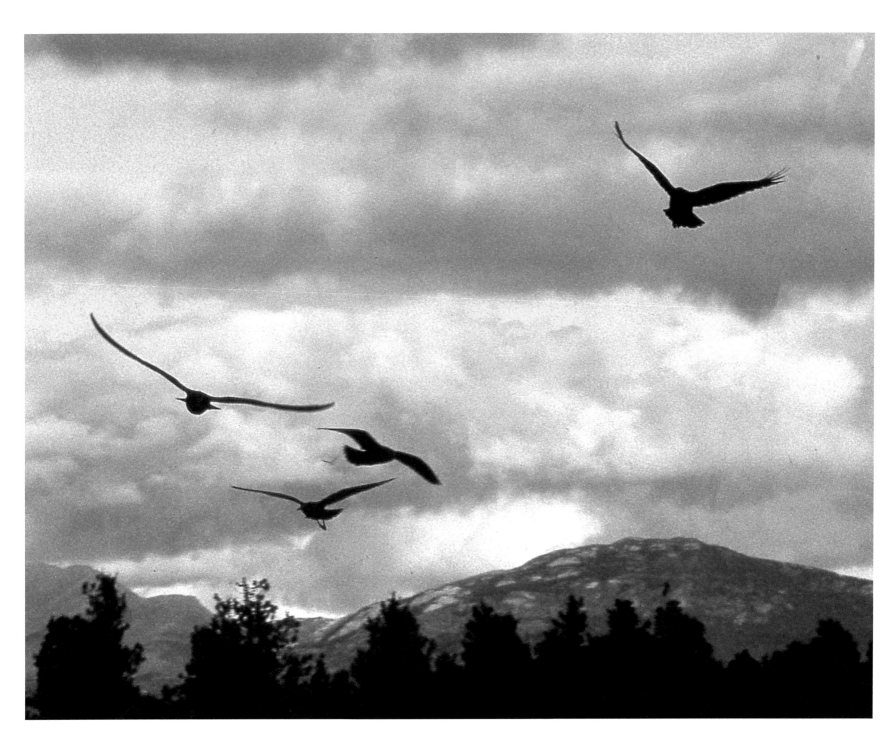

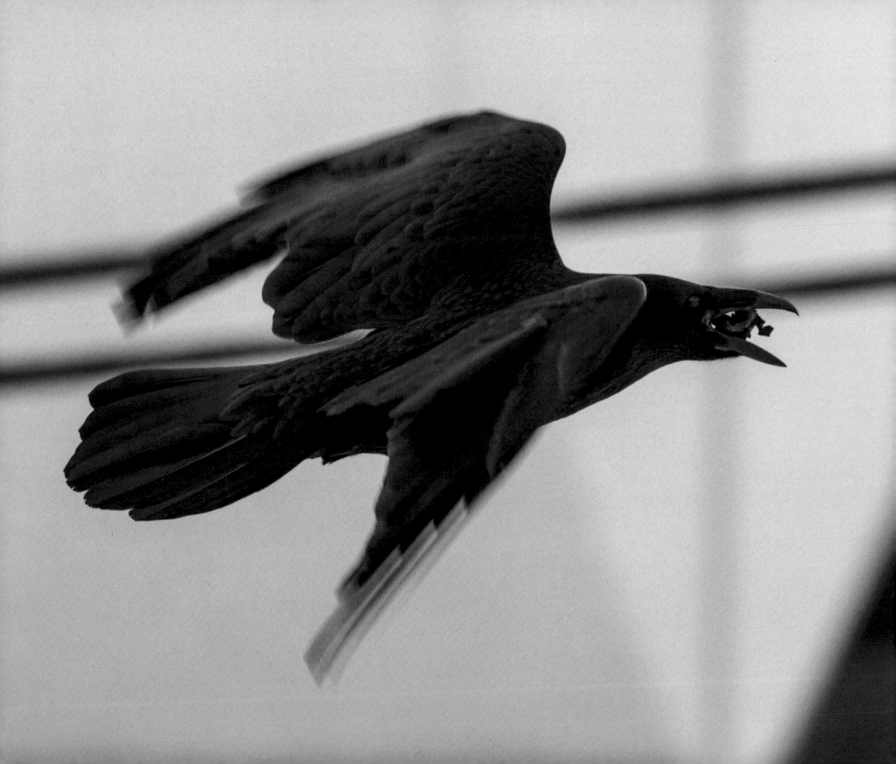

4.

Scavenger

Many, many years ago, it was said that animals and humans communicated with one another.

There lived a seagull, a wolverine, and a wolf. They all entered an iglu and brought meat to that household. The seagull brought a char. The wolf and wolverine brought caribou for the feast. The raven brought frozen dog feces.

Someone said to the raven, "You brought that to the feast? Go outside and eat it yourself." Feces weren't proper meat to feast on.

This was a legend I heard as a child growing up with my adoptive parents. They heard it from their ancestors. To this day, ravens go near dogs. They are known to eat the feces of all animals.

Mabel Ekvanna Angulalik
Cambridge Bay, NU

I was checking my traps one day. I had my cane with me. I also had a rifle on my back. I got close to my traps, and with my own eyesight, I saw a raven in my traps. I didn't feel right shooting the raven with my rifle. I was going to scare it off with my cane. I looked again, and it was a wolverine. I started rushing to get my rifle off my back. I knew what had just occurred and I was scared. When I was trying to hit the raven, the raven tried to bite my cane. I almost fell backwards. At the time I was alone. In the old days, we were mostly alone.

When I saw the raven in the trap, I scolded the raven and said, "Why are you trapped here when there's other meat around? You could have had some eyeballs from the caribou meat."

I had a cache of meat not too far from the trap. I scolded the raven. It was scary. They have eyes just like human eyes. Somehow it knew I was going to hit it with my cane. That amazed me. People used to be on the land together, but they used to go in different directions to set their traps.

Most people know that ravens don't land near people, only far away from people, when we are skinning animals. But one came and another one came and they really started making noise. One was digging in the ground. I got really scared. I was tempted to go see what it was, what they were digging for, but then I thought I should try to pray. I thought if I were to go over there, something might happen, so I just left them alone. I left, trying to get closer to the wolves I was trying to catch.

I said to the ravens, "Come and help me get those wolves and you can have the eyeballs." It was like they listened and left.

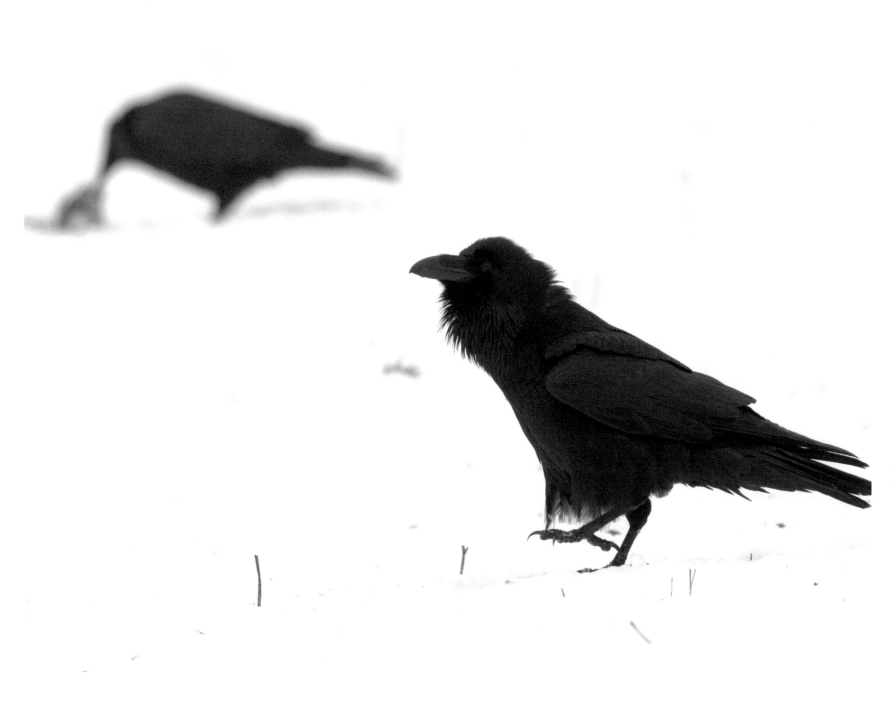

Then I caught those wolves. Sure enough, they ate the eyeballs. Wolves are really hard to catch because they've got good hearing and their eyes are really good. They are really hard to get close to, but these two I caught, maybe because of the ravens. My father taught me never to make fun of ravens. They guide the hunters and they're always with the hunters whenever there are animals around.

When you see them from far away and they're getting closer, people ask, "Where's all the meat? Where's all the meat?" And they start flapping, making a sign, indicating that there are animals close by, to tell you that there is caribou or something to hunt.

Connie Nelvana
Kugluktuk, NU

When we used to go hunting, Inuit used nature to help them out. They often say, when you are travelling and caribou hunting, if you see a raven, it will circle around the hunter and take off. You follow them because they also want to eat something, too.

Germaine Arnaktauyok
Yellowknife, NT

My brother-in-law was once so disappointed at finding a raven in his traps instead of a fox that he went to that raven and cut off its foot. While he was busy fixing the trap, he took his mitts off and put them on the ground. The raven picked up the mitts and flew away. His hands were frozen and he was travelling and had no mitts.

Connie Nelvana
Kugluktuk, NU

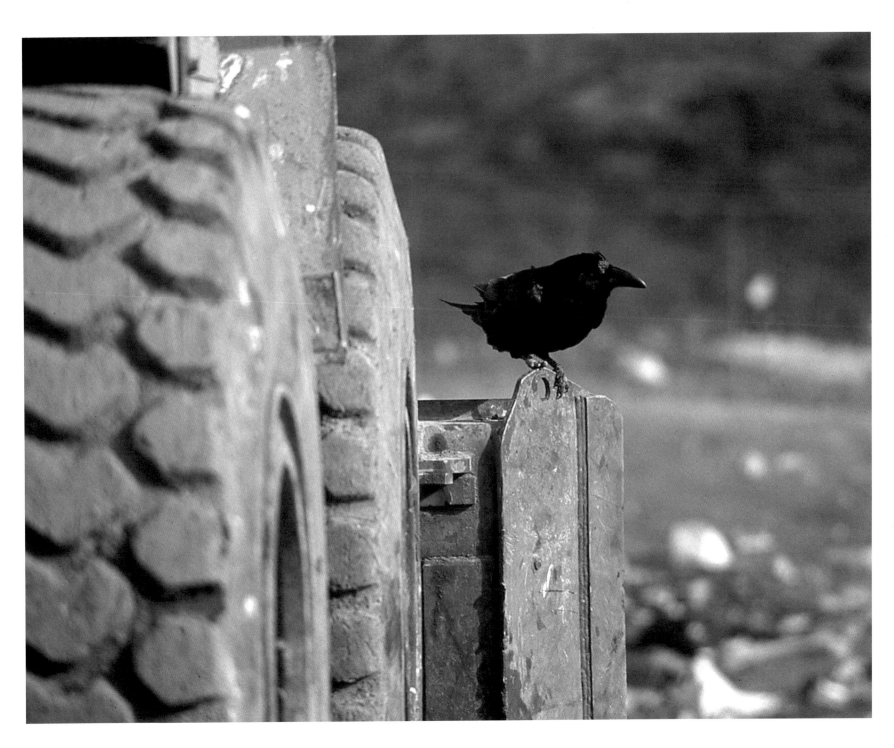

We used the ravens as an indicator, from the knowledge of our legends, to tell us where the caribou were. In the dog team days, it would take forever to go five miles, so our people learned from experience that the ravens would point out caribou to us just by the way they flew.

For instance, if we were travelling and going caribou hunting and we saw a raven flying, we would watch it and keep an eye on it. It would start to dip and do some wingovers and go down and come up and drop and start flying again. That told us immediately there were caribou there. We don't know for what reason, but the ravens always do that.

When I'm teaching my son and passing on the art of hunting, this is one thing I always tell him. Even if we see the caribou, I tell him to watch the raven flying over. As soon as it flies over a small herd, or any herd, it will do some wingovers and dip down and up.

The boy would say, "Dad, that's a great legend."

It teaches us that the ravens really do this. The ravens talk to us that way. The Elders say the reason they do that is because they want to consume some fresh caribou guts or fat or things we leave behind. They're on the lookout for fresh food.

We feed our Creators.

Roy Goose
Cambridge Bay, NU

There were only a handful of ravens when people lived in camps, before we moved into communities that are populated, because at that time not many people lived together in one place. It is when we move into a community and there is a permanent landfill that so many more ravens are noticed.

The behaviour of the ravens was very different with few ravens around, when we survived only on hunting and living the traditional Inuit life. Men, and even us women, used the ravens as indicators. It is said that the ravens used to warn people that there was a presence nearby, and let them know that it was most likely a polar bear, just by the way they made noises, other than the "qaa, qaa" noise.

The people would know there was a polar bear nearby in that area just by observing the behaviour of the raven near the ice or the land. The raven would be almost dancing around and looking excited and seeming like it was

trying to get their attention, different from when they are just flying around. The men were grateful for that indicator.

When the men were out hunting and only children and women were left in the camp, the ravens used to warn us about a presence nearby by twirling around and seeming nervous, different from the raven just trying to find food around us. That is what was known by us Inuit. They were a very important part of our lives because they were indicators of danger nearby.

Today the behaviours of ravens are very different and they are now even taking food away from the poor dogs, because the dogs are now just tied down and people don't bother to bring the dogs inside their homes anymore to feed them. They're just left alone to fend for themselves. That is why the ravens are so bothersome. That is the difference from when we lived a traditional life, before we moved into communities. That is what I know about living with the ravens.

Qaapik Attagutsiak
Arctic Bay, NU

People used to eat the raven. Just like turkey, the raven has white meat. Although I have never tried it, I have heard that it is delicious when cooked. Owls used to be hunted for food also. I have eaten owl meat before, but I have never eaten raven.

They say imitation is the highest form of flattery. The hunter imitated the raven, "Qu, Qu," commanding his dog team to go faster! As an important character in Inuit society, the raven was never hunted for dog food. The raven's wings, once nicely dried, were used as brooms. The raven was important.

Once in a while, the raven was used as bait in fox traps. The dead, frozen raven was placed on a pile of snow beside the fox trap. The ravens, indeed, were very important to Inuit.

Today the raven is no longer considered important. No one cares for the raven, and everyone thinks the raven is bothersome.

Ravens were once part of the beautiful scenery. The sensation of hearing the welcomed call of the raven when we travelled long distances by dog team . . . meant there was human activity.

Atagutak Ipeelie
Arctic Bay, NU

I can also say the ravens have always been bothersome, especially when we relied on trapping to make money. When we had many traps to tend to and we had to trap many foxes, it seemed the ravens destroyed the nice pelts, and in that way they always have been bothersome. It seemed that all the nice fox pelts, which would be more profitable, were eaten by ravens. Because they are so bothersome now for the dogs, I would order a cull to cut the population of ravens, because we no longer rely on trapping far from the communities. The ravens used to bother the traps by eating the bait. The bait Inuit used at that time was a piece of meat, skin, flipper, or the head of an animal. When there was an abundance of food available, the fermented meat was the best bait when they trapped for foxes. I cannot really say how it is now with ravens because I no longer go out on the land to go hunting, but I can tell you that when Inuit trapped foxes the fermented meat was said to be the best bait. It was also the favourite of the ravens to pick at and eat. That was bothersome to people.

Qaapik Attagutsiak
Arctic Bay, NU

It's known the raven cannot leave the Arctic, even in the coldest, harshest of winters. It's so amazing that their feet and wings and beaks cannot freeze. Their feet look funny with all those little bumps. I am always amazed at how they live. We are not like ravens. When you go in the cold with your rubber boots on, they freeze. I've always wondered how they live here year-round.

Moses Koihok
Cambridge Bay, NU

There are too many ravens now in the communities, and they are no longer useful to us as indicators. They even ate dog feces as part of their diet . . . When we travelled by dog team the dogs would poop as we were travelling and the ravens would just follow the dog team tracks and eat the dog feces. This was more noticeable when it was deep winter and the seals and animals were no longer around. That was the only known diet

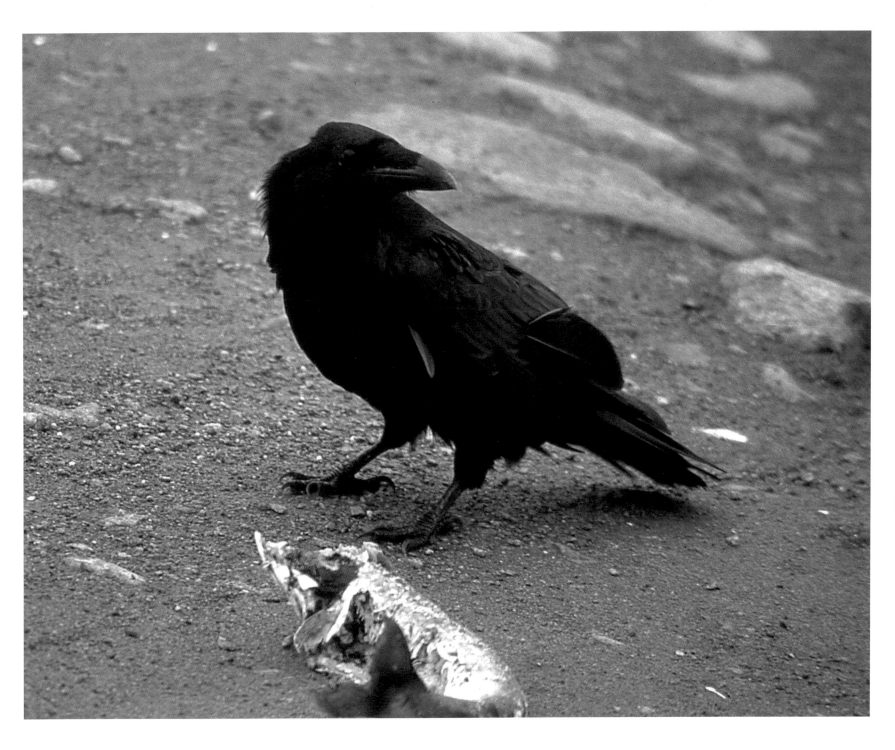

for the ravens. Of course, they would also surround the animal-cutting area and would sneak in and take meat once in a while. But the seagull ate meat all the time in the springtime. I know the raven used to eat meat, too, but I don't recall the ravens ever eating seal meat. I don't know where they get their food from. All I know is they do not eat animal fat as much as the seagull because the seagulls eat a lot of fat and that is their favourite food. That is what separates the raven from the seagull.

Ravens were very shy of people. I don't know why; maybe because they were not known to be around people, or maybe because food was not kept out in the open. But now they are just like dogs. They can even eat with the dogs now. It seems like they are human pets.

Qaapik Attagutsiak
Arctic Bay, NU

Sometimes you're walking out on the tundra and you'll come across a dead raven. It's late spring, and it's really the end of the worst period we've had to go through, so they starve to death. My experience is that they're somewhat cannibalistic, too. Ravens, in dire straits, will come down and feed off a dead raven, so sometimes you just find a shell and feathers. They're really pretty resourceful. The main source of food for most ravens in most of our communities is dead caribou carcasses, the leftovers. I have seen them feed on seal as well, pretty well anything left out there. I can't leave kibble in the back of my truck because they'll just go through it like nothing. You never put garbage bags in the back of the truck and expect them to be intact. There's a sentry system set up. If there's a possibility of food, there may be some sort of signal for the others to come and congregate. They mate for life. I've often wondered, if you had a dead raven and threw it up on the roof, would it be a sign to the others to stay clear?

Rick Armstrong
Iqaluit, NU

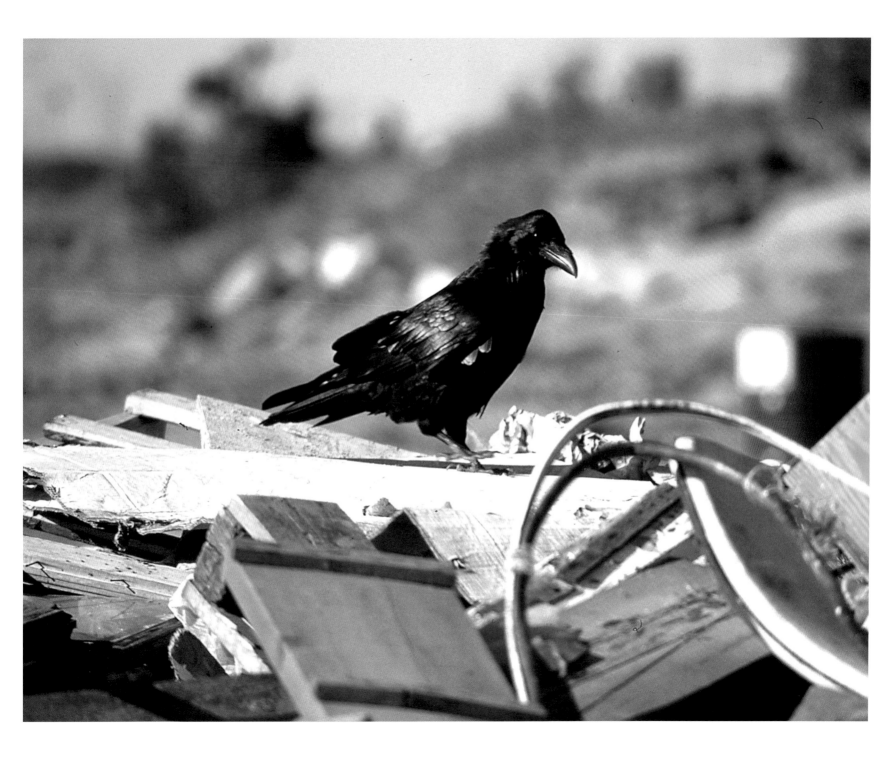

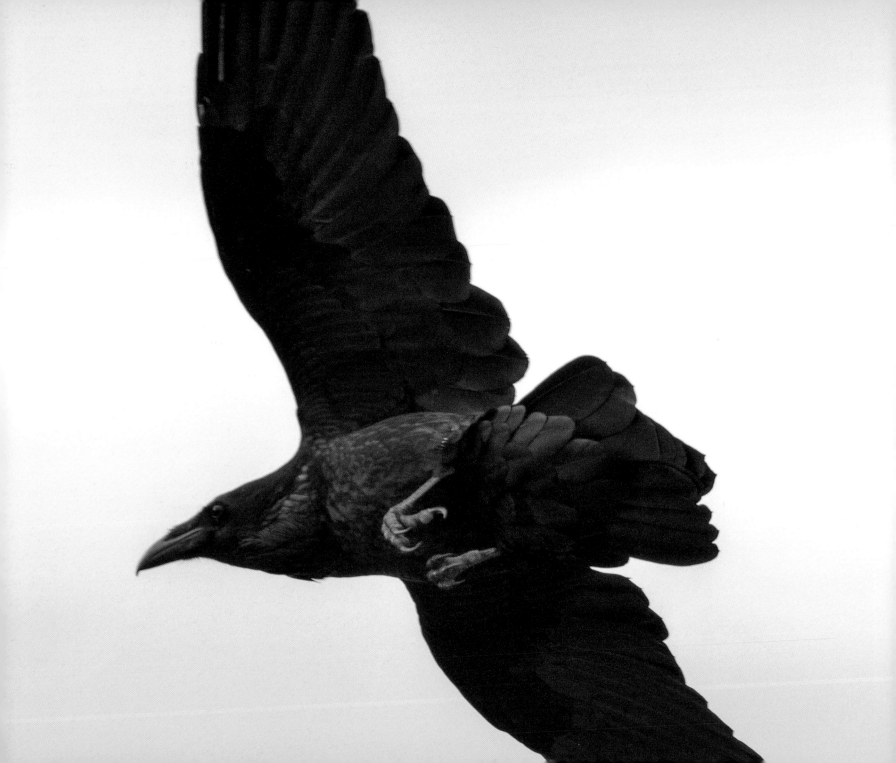

5.

Doom and Gloom

I am a raven. I can live in the harshest climate in the world. I am a scavenger and a predator who hunts for any available prey I can find. I look for water and melted snow to drink. Because I can't make fire, I use the only available heat source I have to melt snow in blowing winter—my body. I have been seen in the warmest climates in the world, too, only in smaller size and adapted to the game in the jungle. I also scavenge from other animals. I have been living since the beginning of time. I saw the world change. Histories made and end. I can harm people who don't treat me properly or who harm me.

One day I was flying, searching for food. I saw a fox, and it wasn't moving. It was stuck in the same spot. I dove down and started to eat the fox. As I was eating, I saw this human being approaching, so I flew away and waited for him to go away. When he left the fox, I went to eat some more. When I was approaching the carcass, I jumped and jumped and fell into a trap. The human being came back and caught me, poked out my eyes, and let me fly away. Because he did this to me, I made a promise of vengeance.

I learned to fly and survive without seeing, with the help of a friend from my ancestral hunting grounds. One day, during a whiteout, the human being who poked out my eyes was going home from hunting. I commanded the weather to get worse, and my request was rewarded. The human being's dogs couldn't walk anymore, so the man started walking. As he was walking, I guided him down a pathway and let him fall into a hole and he got stuck. He couldn't move. I flew beside him and waited for the weather to clear. Finally I would have my revenge. The man saw me and shouted at me to go away. I approached him and poked his eyes out and ate them. Then I flew away to let the man die without ever seeing again.

Levi Barnabas
Arctic Bay, NU

When the *qallunaat* were just arriving to our country, we still relied on wildlife. We still relied on seagull feathers as our main cleaning feathers to wipe ourselves after eating seals or ptarmigans.

My parents used to catch ravens, and maybe because they had black feathers, they dried the feathers and used them for cleaning animal blood or oil that was hard to clean.

Atagutak Ipeelie
Arctic Bay, NU

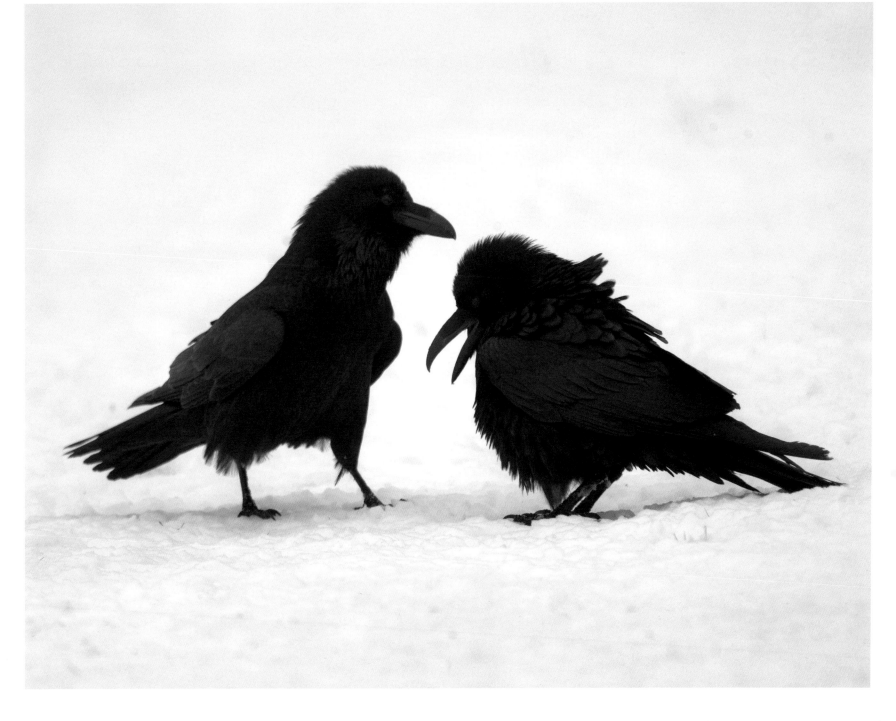

The story that I have heard goes like this: Long ago, long, long time ago, boaters had gone out and were stranded. I heard this story from my grandmother. A raven was asked, since it was very close by and it seemed like it was going to land right beside the person. The person who was walking around searching for the relatives that had not returned from boating asked the raven, "Have you not seen the boaters?"

"Qava, qava."

"Where are they?"

"Down there, they got stranded on the ice, down there."

Unfortunately, they died. The current moving the ice had overpowered their boat and squashed it. The raven notified the person. That was how stories had been passed on to us.

Naki Ekho
Iqaluit, NU

I remember being in Cape Dorset one time as a teacher many years ago. I was walking to the dump, and I had a gun. Any time you leave town, you take one, because there could be bears. The ravens seemed to be able to detect when a person had a gun and could do them some harm. They would stay clear of me as soon as they saw it.

Rick Armstrong
Iqaluit, NU

We have cats. The cats go outside and will normally stay pretty close to the house. The ravens are curious about the cats, and have done to the cats the same thing they do to dogs. I was working on the entranceway a couple of years ago and was in and out of the house. My cats were in the same general area, and I became aware that I had not seen the cats. When I went outside, there were four ravens and the cat was in the centre. The four birds had circled the cat and the cat looked like she wanted to jump but had no way to jump. From the condition of her tail, I could tell that it was the same game they played with the dogs. Whatever way the cat was looking, the raven at her back would

take a crack at her. As she turned, they simply adjusted the attack on her until they got her. They're big enough that I think they could probably kill a cat quite easily.

T. Bert Rose
Iqaluit, NU

We also used to kill the ravens, maybe because we did not understand. Inside them, in their intestines, there is fat that we call *qalliuti*, meaning fat on the outer intestines. The intestines used to be thrown to the water because they could calm the waters.

That was the belief of the Inuit. Yes, part of it is credible, and the ravens are very smart when you go out hunting for food, even up to today.

Celestine Erkidjuk
Iqaluit, NU

It is told that a raven was flying above carrying something that was quite long.

The person called, "*Tulugaaq piksumaa! Kisuna kingmiaqpiuk*? Raven, up there! What is it that you carry? What is it that you carry?"

And the raven replied, "*Inuup qukturaa.* A human limb."

"*Suurli aijjujjanngilarmaa*? Why don't you offer me some?" asked the Inuk.

"*Mamaarigaku iivara.* I like the taste, so I eat it," the raven called.

Back then, the deceased weren't placed in coffins. I imagine the human limb might have been lying around like a piece of animal carcass and the raven found it.

Atagutak Ipeelie
Arctic Bay, NU

My friends and I decided to build a fort after a blizzard that occurred here in Iqaluit. We started digging and digging, and all of a sudden, I hit a clink. Was that a rock? We started trying to dig around to make our fort bigger. It turned out it was a frozen raven. We took the raven out and, like kids would do, started taking it apart and looking at it in more detail. That's the gist of it. We took it to the wildlife guys after that. It was stinky and rock hard. The wings practically snapped right off it. It's always stuck in my mind, that raven.

Jonathan Ellsworth
Iqaluit, NU

It was getting to be winter and everything was changing. Our house was up on stilts. This raven was on top of the water shed. I was standing on the road and it was above me. It was so bizarre. It was all puffed up, you know how they get. It was making this call, the normal caw they do. I was looking at it. It made that call in one direction and then it turned toward my house and it made the call. The call went underneath my house and bounced back as an echo. It turned toward the east and made the call again and then turned back to me and made the call again. It was sending out some sort of call. Just as it finished the last call, it took off and came down and swooped a foot from my head and then went up and circled around and came back and swooped at my head a second time. It came within a foot of my head, twice, and then sat back up on the water shed. It scared the shit out of me.

Their beaks are three inches long. If the beak went through my head, I would be quite dead. It made me start thinking about them. What did that mean? I figured he was trying to tell me, "This is my area, my place. I'm in control here." My friend, who I told the story to, said he figured the raven was saying, "Give me some food."

Tanya Tighe
Yellowknife, NT

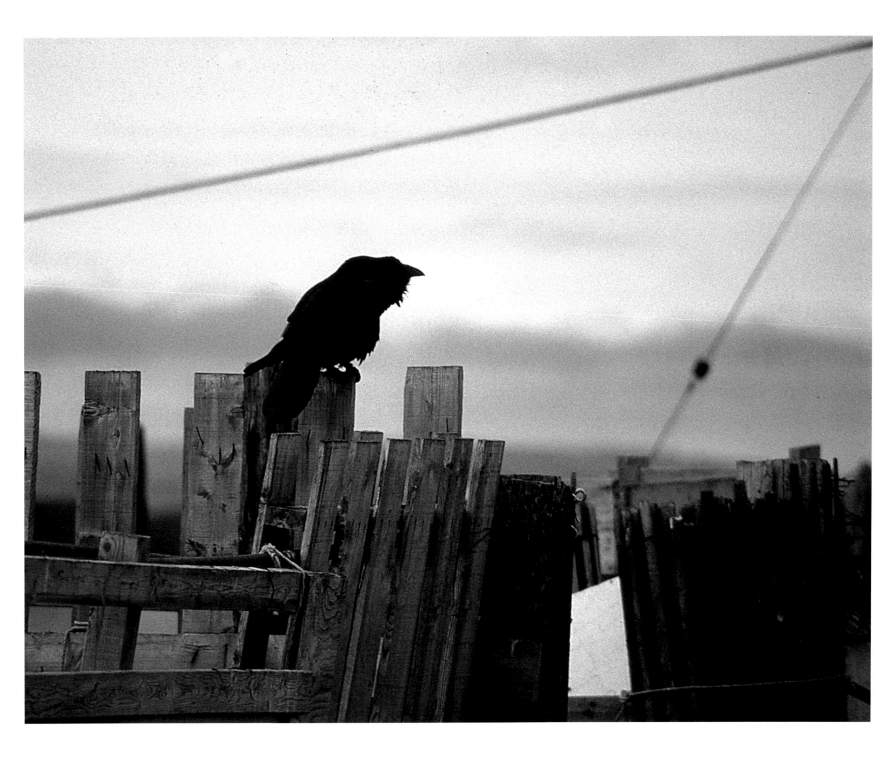

Shaman was hunting and saw Raven flying and carrying something.

Shaman asked Raven, "What are you carrying?"

Raven replied, "Part of a man's leg."

Shaman asked if the raven could share the leg, because he was hunting for food.

The raven replied, "No, I really like it, I won't share it."

Levi Barnabas
Arctic Bay, NU

This is a very recent story here, as a matter of fact. This old man, Simon Niaqunnuaq, he just died recently. He was at his window sitting down having tea. The ravens, of course, are always entertaining to watch. They're always flying around. He said he saw one on the ground that was obviously sick. There was something wrong with it. He watched this other raven up in the sky. It came down and walked around the raven three or four times, and the sick raven was suddenly better and it flew away. That's weird. This was a second-hand story of the raven. I heard it from the person he told it to.

Bob Lyall
Taloyoak, NU

When ravens felt sorry for foxes that were trapped, they used to eat them, because they get hungry, too. Ravens cannot be mocked or mistreated or abused, as my late brother told me. He was once checking his traps—his traps had bait that the ravens were getting at. When he checked his traps, he found that a raven, feeling sorry for the fox in the trap, had eaten it alive, and it was all gone. He set his trap for the raven this time and trapped it and cut its feet off almost at the top. Then, when he tried standing up, after he had cut the raven's feet, he could feel a breeze in both his legs. He tried getting up so many times, but he could not stand up because his legs were very swollen because he had severed the raven's feet. The raven got back at him that way. He learned his lesson and would never mistreat or abuse ravens in any way after that.

Naki Ekho
Iqaluit, NU

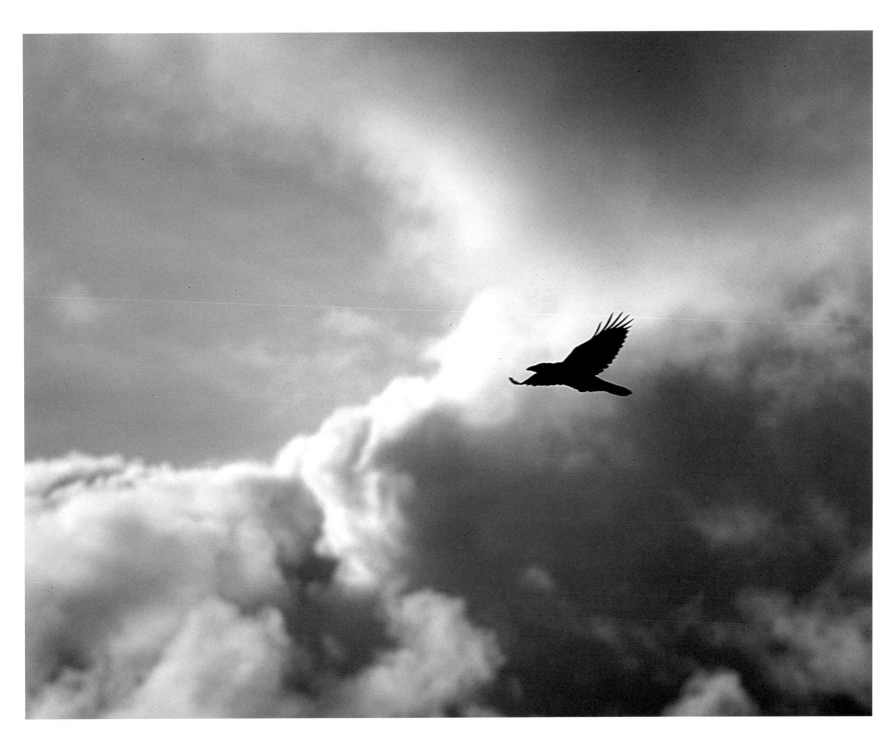

In the 1950s, the Government of Canada initiated a wolf-control plan, paying a bounty of forty dollars for each wolf. Wolves, according to biologists, were overpopulating the earth and bothering people's traplines and attacking their source of income.

What wolves do on a trapline is go to a trap where there is a white fox or a red fox, or a wolverine, or whatever it may be, and they go to that captured animal and kill it for no reason at all. We say the wolf recognizes the animal is held and has nowhere else to go, so they kill it, maybe out of mercy or just for fun. The government had this wolf-control program, and all the hunters had to do in order to prove they got a wolf was to bring in the tail. The Hudson's Bay Company gathered these tails and paid the hunters a bounty of forty dollars apiece. In the 1950s, forty dollars was substantial. That led people to go after wolves a lot more and to use more interesting tools.

One tool that was deadly, and that was introduced to Inuit across the Arctic, was strychnine. The government taught people in the communities how to use strychnine and taught them how dangerous this was. They were instructed on the kind of mitts to use when handling it and to use it only for that purpose and not to touch any other meat. They got all these caribou in the falltime and laced them with strychnine and spread the poison throughout the whole carcass. These poisoned caribou carcasses would be laid out in all parts of the land. By word of mouth, they would tell the other hunters where the carcasses would be so they would avoid camping in that area or having loose dogs in the area. Anything that touched or ate those carcasses would die. Foxes or carrion birds, especially the raven, would be killed as a result of ingesting this poison.

At that time, there were ravens all over the place. People would see them all over the island and the mainland. As a result of that wolf-kill program, a lot of ravens were killed off, and pretty soon, we didn't see them anymore. They weren't as common as they used to be. But, starting in the late 1980s, we started to see them come back and populate the area. Now, we're seeing them all over the place. They fly, they clean up the land, and that's what we recognize them as. For sure they disappeared. The ravens learned as a result of dead ravens lying there, and they knew not to approach that poisoned meat.

Roy Goose
Cambridge Bay, NU

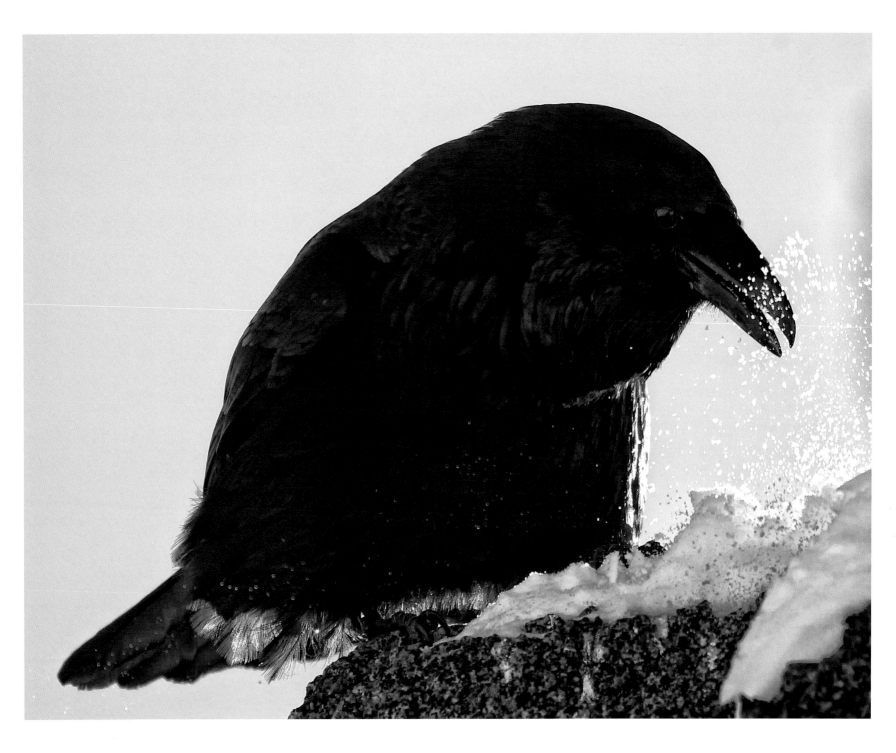

My sons and I were out ptarmigan hunting one time. We saw all these ravens congregated. We went to check what was going on. There was this one *tulugaq*, which was still alive, and they had plucked his head like a Mohawk cut, except it was plucked down the middle. It must have done something awfully wrong to deserve that kind of treatment from its fellow ravens. We just left it. The ravens probably came back later on and finished it off. It was strange. The top of its head was plucked, like it was picked at. It wasn't able to fly away.

I have a love-hate relationship with ravens. I will call them down, but they also keep me entertained. One of the things that really pisses me off about them is you have to pick up after them if you don't take good care of your garbage. I was once really mad at a raven. It was standing on top of my house. I was picking up garbage and I was getting madder by the minute. I picked up a rock and I threw it at the raven. It was a heavier rock. It sort of floated toward the window and hit the window and there was a big pop. The ravens were laughing at me because I broke the window. Everyone's got a raven story. They even talked about culling them around here because there are so many of them. But they say if you shoot one, they won't come around for a long time.

Bob Lyall
Taloyoak, NU

In order to discourage seagulls and ravens from attacking the dry fish and drying meat in our camps, we get one of those birds, preferably a seagull, and hang it by its neck on a pole beside the drying fish. The other seagulls see that, and it works. They don't peck away at our fish and meat. That's an important food source for us in the winter.

The same goes for a raven. If it sees a dead seagull, it won't go in the proximity of that dead bird. We don't use a dead raven because we believe strongly that if we touch those birds, it's going to turn the weather bad. That's how our forefathers taught us these were very valuable birds, even though we don't consume them or use their body parts for clothing or decoration or otherwise. In order to have a clean country, we have to have caretakers, and they're our caretakers.

Roy Goose
Cambridge Bay, NU

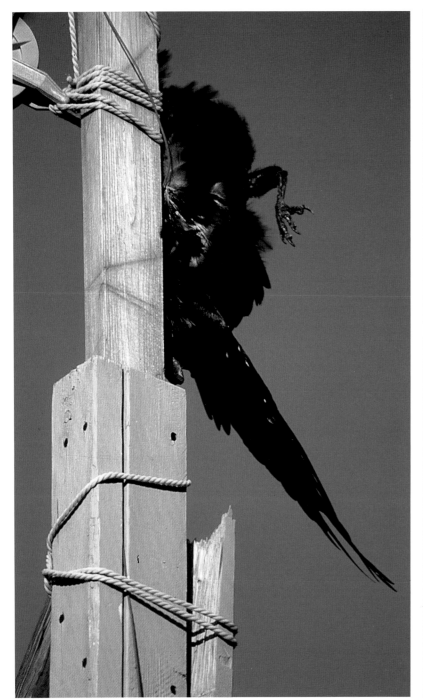
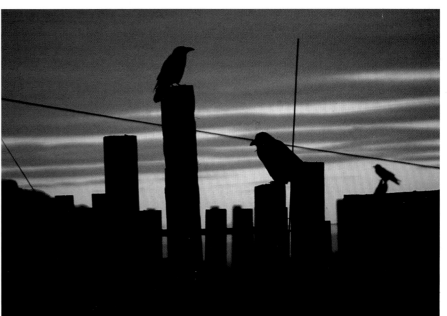
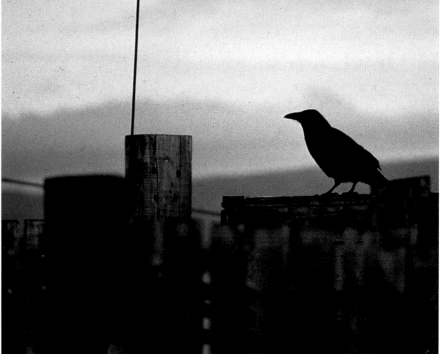

People used to travel with all of their family together. One day, there was a whole group of people travelling to another place.

This raven started saying to the people, "You should go camp over there."

It was at the bottom of a big bank, like a cliff, where the raven was telling them to go and camp and build their shelter. The raven told the people there was another group of people hunting them. The raven scared the people, and they believed the raven, so they built their camps there. They could understand what the raven was saying to them and it really scared them. The raven told them other people were coming and they were probably going to kill them all. The people listened to the raven.

When they settled down for the night, the people were scared, so they dimmed their *qulliit*. There was hardly any light because it was winter. They could hear the raven at the top of the hill jumping up and down on the snow. The raven jumped around all night. Then, slowly, the snow started to fall, and it killed all the people in an avalanche.

The next day, when it was bright outside, some people passed by and saw all the dead people. The dogs were all dead, too, all from the avalanche the raven had made. The people couldn't do very much about it because they were on their way to another place, so they didn't have time to gather up the dead people. The raven was very happy about the dead people and the dead dogs. He was going to have lots of eyeballs to eat. That's why he lied to the people and made them build their iglus there.

Lilly Angnahiak Klengenberg
Kugluktuk, NU

There is this ridge of rock before Ndilo. I was watching this cat come down the face of rock. It was climbing really carefully. You could tell it was in stalking mode. Three or four feet ahead was this raven. It seemed to be hurt, because it was hopping a little bit at a time. The cat thought it was smart and was getting closer and closer and closer. As the cat started to zero in, the raven stopped and made this call . . . and all of a sudden, I see a raven come in and land way behind the cat on top of the rock. The other bird kept calling. As this cat thought he was getting close to his meal, I saw another raven land beside the first one. They kept landing. There were ten of them—it was like this SWAT team—until they had this cat completely surrounded. The cat had no idea, until he was

about to pounce on the first raven and he looked behind him. When he saw all the ravens slowly moving in on him he took off so fast. It was like a military thing. He called in these ravens and they knew exactly what positions to take and what to do. That cat had no chance. I think they were using the cat for practice. I think the raven was using the cat, baiting the cat so they could practice their military strategies.

It was like *The Birds*. First there was one, then there were two, and then there were too many.

Tanya Tighe
Yellowknife, NT

Contributors

Photographs do not represent all contributors; a complete list begins on page 88. Ishmael Alunik, Mabel Ekvanna Angulalik, Rick Armstrong, Qaapik Attagutsiak, Levi Barnabas, Muriel Betsina, Cathie Bolstad, Inusiq Davidee, Naki Ekho

Celestine Erkidjuk, Roy Goose, Attima Hadlari, Leah Idlout-Paulson, Atagutak Ipeelie, pj johnson, Mackie Kaosoni, Lilly Angnahiak Klengenberg, Moses Koihok

Kerry McCluskey, Hans Nelles, Connie Nelvana, Chuck Pizzo-Lyall, T. Bert Rose, Enuapik Sagiaqtuq, Tanya Tighe, Annie Tiglik

Ishmael Alunik was an Inupiaq Elder who was born in Old Crow, Yukon Territory, and lived much of his life in Inuvik, Northwest Territories. He passed away in 2007.

Mabel Ekvanna Angulalik was an Inuk Elder who was born in 1925 and lived in Cambridge Bay, Nunavut, for much of her life. She passed away in 2002.

Rick Armstrong is a long-time Northerner living in Iqaluit, Nunavut. He works at the Nunavut Research Institute.

Germaine Arnaktauyok is an internationally renowned Inuk artist living in Yellowknife, Northwest Territories.

Qaapik Attagutsiak was born in the Kivalliq area of Nunavut, in a place called Siuraq, in 1920. She currently lives in Arctic Bay, Nunavut.

Levi Barnabas served as the first Speaker of the House in the Nunavut Legislative Assembly. He lives in Arctic Bay, Nunavut, with his wife and children.

Muriel Betsina is a Dene Elder who currently resides in Ndilo, a community located close to Yellowknife, Northwest Territories.

Cathie Bolstad is a life-long Northern resident who continues to live in Yellowknife, Northwest Territories, with her husband. They are frequently visited by ravens and take pleasure in their antics.

Dorothy Carseen is from Gameti, Northwest Territories. In 1993, she produced a photography show that featured the legends of Tlicho Elders. Some of those legends appear in *Tulugaq*.

David (Daawi) Chocolate was born October 25, 1920, in the Tlicho region of the Northwest Territories. In his early years, he lived with his parents at Hislop Lake, Blackduck camp, Rae Rock, and Behchoko. While living in Behchoko, Daawi married Yaabeh Zoe on September 15, 1947, and after their ninth child was born they moved to Gameti. Throughout his travels, Daawi heard traditional stories from his parents, aunts, uncles, friends, and Elders. As Daawi became very knowledgeable of the land, he taught his sons where to hunt, fish, and trap. He shared the stories that he learned through his travels with his children, school students, and others. Daawi passed away June 13, 1999.

Elizabeth (Yaabeh) Chocolate, who was born April 10, 1927, was five years old when she started to scrape her first caribou hide. From then on, through observation and practice, Yaabeh learned the skills of cutting and cleaning small game and sewing small crafts. Her tanned caribou hides and moosehides turned into beautiful beaded or embroidered traditional clothing for her family. While sewing or working on a project under candlelight, Yaabeh would listen to stories her mother shared with her. She learned more from other elderly women who came to visit her mother in the evenings. After her marriage to Daawi Chocolate, she learned more stories as they lived out on the land with their children. Yaabeh shared the stories she learned with her own daughters and local girls who came to visit. Yaabeh also taught school students her traditional skills and the stories that her parents and Elders passed on to her. Yaabeh passed away December 24, 2006.

Inusiq Davidee was born in Cape Dorset, Nunavut. She moved to Iqaluit, Nunavut, by dog team around 1968. She passed away a few years ago.

Naki Ekho was born sometime around 1915 near a whaling station outside Pangnirtung, Nunavut. In 1957, she and her family moved to Iqaluit, Nunavut, by dog team. She passed away in 2000.

Jonathan Ellsworth grew up in Iqaluit, and continues to live in Nunavut's capital with his partner and family.

Arnold Enge was born and raised in Frobisher Bay (now Iqaluit). He is an avid golfer on the sand fairways of Yellowknife.

Celestine Erkidjuk was born in Chesterfield Inlet, Nunavut, in 1930. He moved his family to Iqaluit, Nunavut, in 1963. He passed away in Iqaluit in 2011.

Roy Goose learned many of the legends he knows from his great-grandmother, Naimee Mammayuk, who left Alaska and came to Canada around 1910 with the Arctic explorer Vilhjalmur Steffansson. Roy passed his legends on to his children to teach them important life lessons and morals.

Attima Hadlari lives in Cambridge Bay, Nunavut. His mother told him the story of the fox and the raven.

Walt Humphries is a prospector and writer living in Yellowknife, Northwest Territories.

Lucie Idlout is an Inuk singer/songwriter who currently resides in Igloolik, Nunavut. Her music has won national and international acclaim since 2004.

Leah Idlout-Paulson worked as an Inuktitut interpreter and translator for many years. She is an Elder who currently lives in Iqaluit, Nunavut.

Atagutak Ipeelie was born in a *qammaq* (sod house) in 1929 in Ikpiarjuk, Arctic Bay, Nunavut. Her father, Ivalaaq, and her mother, Qannakuttuk, told her the stories she knows about ravens. She currently resides in Arctic Bay.

pj johnson was named the Yukon's first Poet Laureate in 1994. Known as the "Raven Lady," many credit her with winning the fight to have the raven named the territorial bird of the Yukon. pj is also a singer/songwriter, actress, playwright, and storyteller.

Mackie Kaosoni was born near Holman Island, Northwest Territories, before moving to Perry River, Nunavut, and finally to Cambridge Bay, Nunavut, with his wife and children in 1952. He passed away in 2000.

Lilly Angnahiak Klengenberg was born December 25, 1922, on Victoria Island, Nunavut, to Rose Kengnektak and Stanley Kellogok. She lived and loved her heritage as a Copper Inuk. Her stories were passed down from her mother, who had in turn learned the stories from her grandmother, Kikhak. These stories have been passed down to her children and all Kugluktukmiut. Before Lilly died, she had her stories written down into Inuinnaqtun and published as books for schools in Kugluktuk, Nunavut.

Moses Koihok is an Inuk Elder. He moved from the Bathurst Inlet area of Nunavut to Cambridge Bay, Nunavut, in 1959. He is currently Cambridge Bay's oldest resident.

Mikle Langehan is an Inuktitut interpreter and translator residing in Yellowknife, Northwest Territories.

Bob Lyall lives in Taloyoak, Nunavut, where he serves on various local and regional boards, and fishes for char and trout. He is also still watching ravens.

Kerry McCluskey is raising her son in Iqaluit, Nunavut. Since 1993, she has been working as a journalist and writer in the Arctic, telling the story of the North from bowhead whale hunts and community feasts to the signing of the Nunavut Land Claims Agreement and the creation of Nunavut. In 1999 she began travelling across the Arctic collecting stories, information, photographs, and artwork about ravens from Inuit, First Nations, and non-Aboriginal Northerners alike. *Tulugaq* is the result of this research.

Hans Nelles moved to Haines Junction, Yukon Territory, from Germany. He and his wife opened a gourmet restaurant and hotel called The Raven.

Connie Nelvana was born at Agiak, Nunavut, in 1918 and passed away in 2000. Connie was very proud of our culture and she took every opportunity to share knowledge with those around her.

Chuck Pizzo-Lyall lives in Taloyoak, Nunavut. He works for Canadian North and spends his spare time hunting and camping. He loves being on the land.

T. Bert Rose is a long-time Nunavut resident who occasionally adventures across Canada on his motorcycle.

Enuapik Sagiaqtuq was born April 17, 1929, at Immiligarjuk, near Kimmirut, Nunavut. She currently resides in Iqaluit, Nunavut.

Larry Simpson lived and worked in Iqaluit for many years before seeking retirement in Truro, Nova Scotia.

Tanya Tighe is a former Bullock's Bistro employee who was once nearly attacked by a raven.

Annie Tiglik is an Inuk Elder who was born May 30, 1939, at Illutalik, near Pangnirtung. She has lived for many years in Apex, Nunavut, a small community located outside Iqaluit.

Acknowledgments

Many people and organizations helped bring *Tulugaq* to life. Support in the form of funding and travel came from the Government of Nunavut, Government of Canada, Canadian North, and Kenn Borek Air Ltd. Many, many thanks.

Over the last several years, many friends, interpreters, translators, photographers, and guides provided encouragement, food, lodgings, ATVs, boats, support, and services: my parents and family, Peggy Adjun, John Agnew, Aime Ahegona, Emily Angulalik, Martha Angulalik, Alethea Aggiuq Arnaquq-Baril, Kataisee Attagutsiak, Joanna Awa, Jorge Barrera, Renata and Sam Bullock, Betty Brewster, Linda Callaghan, Maria Canton, Fred and Patti Cornellson, Dorothy Carseen, Elisa Chandler, Nadia Ciccone, Jim Currie, Kirt Ejesiak, Edna Elias, Ron Elliott, Qajaaq Ellsworth, Steven Foulds, Cecilia Fox, Justin Goyer, Wende Halonen, Jeremy Hamburg, Donald Havioyak, Brad Hickes, Josh, Gladstone, Carol, and Murray Horn, Midori Hyndman, Leah Idlout-Paulson, Elisapee Ikkidluak, Innirvik Support Services, Paul Irngaut, Allen Kitigon, Helen K. Klengenberg, Millie Kuliktana, David Michael Lamb, Mikle Langehan, Allice Legatt, Carmen Loberg, Dan Kane, Stacey Aglok MacDonald, Marcel Mason, Malaya Mikijuk, Peter Nakoolak, Suzie Napayok, Kelvin Ng, Katie Niptaniak, Northern News Services Ltd., Nunavut Youth Consulting, Natan Obed, Darrell Ohokannoak, Madelaine Pasquayak, David Pelly, Rita Goyer Pigulak, Robby Qammaniq, Maggie Qappik, Inusiq Qavavau, Tony Rose, Mads Sandbakken, Suzy Schwartz, Mike Scott, June Shappa, Ross Sheppard, Jack Sigvaldason, Aaron Spitzer, Craig and Erin Stevens, Terra Tailleur, Joanne and Peter Taptuna, Tommy Tatatoapik, Manitok Thompson, Martha Tiglik, Mona Tiktalik, Bruce Valpy, Leslie Campbell Valpy, Glenn Williams, Mary Wilman, Susan Woodley, Jonathan Wright, and Arthur Yuan. If I have forgotten anyone, I apologize: it took me so long to finish this book that my memory may have faded.

A million thanks to everyone who took the time to contribute to *Tulugaq*. A million thanks to Inhabit Media Inc. for publishing this work. A million more thanks to the *tulukkat* for the inspiration, the trickery, and the humour.

Qujannamiik

For more information, visit www.tulugaq.com.